# Shades OF Beauty

THE
COLOR-COORDINATED
WOMAN

Marita Littauer and Florence Littauer

Illustrated by Lou and Carol Police

HARVEST HOUSE PUBLISHERS
Eugene, Oregon 97402

Scriptures are from the King James Version of the Bible.

**SHADES OF BEAUTY**

# Contents

Introduction . . . . . . . . . . . . . . . . . . . . . . . . . . . . . . . . . . 4
1. Color Palettes and Model Photos . . . . . . . . . . . . . . . . . . . 9
   Wave The Magic Wand . . . . . . . . . . . . . . . . . . . . . . . . . 17
2. A Closetful Of Clothes And Nothing To Wear? . . . . . . . . . . . 21
3. My Time's Not Your Time . . . . . . . . . . . . . . . . . . . . . . . . 25
4. Dawn . . . . . . . . . . . . . . . . . . . . . . . . . . . . . . . . . . . . 31
5. Sunrise . . . . . . . . . . . . . . . . . . . . . . . . . . . . . . . . . . . 45
6. Morning . . . . . . . . . . . . . . . . . . . . . . . . . . . . . . . . . . 59
7. High Noon . . . . . . . . . . . . . . . . . . . . . . . . . . . . . . . . . 73
8. Afternoon . . . . . . . . . . . . . . . . . . . . . . . . . . . . . . . . . 87
9. Sunset . . . . . . . . . . . . . . . . . . . . . . . . . . . . . . . . . . . 101
10. Evening . . . . . . . . . . . . . . . . . . . . . . . . . . . . . . . . . . 113
11. Midnight . . . . . . . . . . . . . . . . . . . . . . . . . . . . . . . . . 127
12. Start With What You Have . . . . . . . . . . . . . . . . . . . . . . . 143
13. How To Have A Winning Wardrobe . . . . . . . . . . . . . . . . . 151
14. Cosmetics — The Finishing Touch . . . . . . . . . . . . . . . . . . 161
15. Surround Yourself With Shades Of Beauty . . . . . . . . . . . . . 181

# Introduction

*"Strength and honour are her clothing."* (Proverbs 31:25)

From the time our daughter Marita was a child, she has been creative with color and concerned with her clothing. Excluding an early teen dip into frayed jeans and tie-dyed T-shirts, she has chosen her own clothes with class, and developed her own style of dress independent of my ideas. She has always enjoyed shopping with me and has had an eye for correct choice of clothing from a very early age.

When I would take her to discount stores where we all tried on clothes together in one big dressing room, she would observe women who were uncertain about what to buy. She would go out to the racks and select some sample outfits which she would present to some unknown lady who would be amazed at this child assistant. Invariably, when the woman tried on the clothes, they would be just right for her and she would purchase them wondering how Marita could find exactly what she'd wanted when she couldn't locate them herself.

This inborn feel for fabric, color, and style led Marita to major in color and design in college and to seek out personalized training at John Robert Powers in Beverly Hills. As Marita began to work with women professionally and they began to respond to her advice, we both saw how quickly women could be transformed when they began to use color correctly. Not only did they look better dressed in their own Shades of Beauty, but their confidence grew as they had the assurance they were well-attired. As they built confidence in their appearance, their personalities blossomed.

When Marita first created her unique color program, she spoke with me at a women's retreat for the First Presbyterian Church in Fresno, California. Many ladies signed up to have their colors done and they all began to carry their custom charts and buy what was right for them. As other women in the church noticed the changes, they asked for appointments and the concept spread. The pastor observed that his congregation looked better and he asked what had happened to his female flock. When his wife explained what Marita had been doing, he signed up for a consultation, followed by one for the assistant pastor.

From this start five years ago, Marita has "colored" the congregation and staff at the First Presbyterian Church and still spends one week a month freshening up new friends in Fresno.

Marita has helped me develop my personal style and she chooses my clothing. We both know what a difference the correct color can make in any individual's looks, personality, and confidence, and we want to share these concepts with you.

We know that you will enjoy finding your own Shades of Beauty and you will say along with thousands of others: COLOR ME CONFIDENT!

—Florence Littauer

# Chapter 1

# Dawn...

Kathy Percy

Sue Dalton

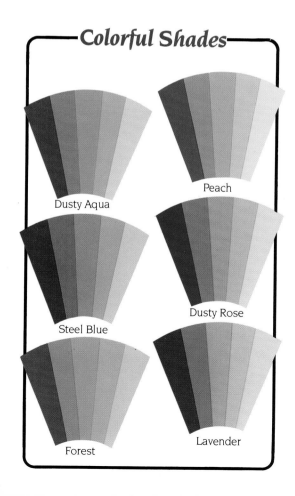

## Colorful Shades

Dusty Aqua

Peach

Steel Blue

Dusty Rose

Forest

Lavender

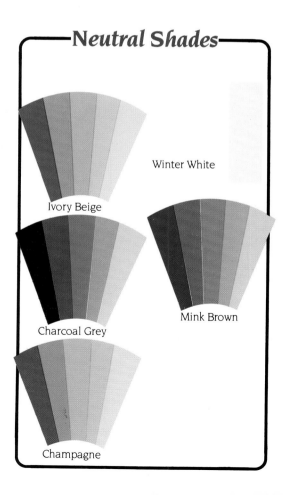

## Neutral Shades

Winter White

Ivory Beige

Charcoal Grey

Mink Brown

Champagne

# Sunrise...

Margie Feramisco

Patty Telles

## Colorful Shades

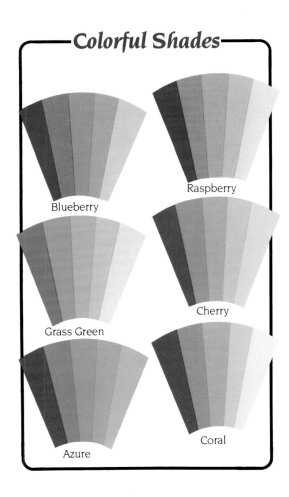

Blueberry

Raspberry

Grass Green

Cherry

Azure

Coral

## Neutral Shades

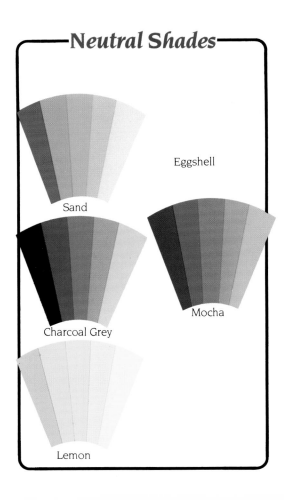

Sand

Eggshell

Charcoal Grey

Mocha

Lemon

# Morning ...

Janice Bruno

Marita Littauer

## Colorful Shades

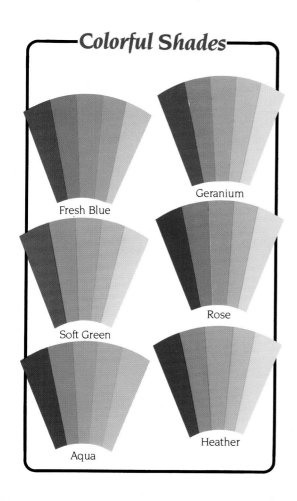

Fresh Blue

Geranium

Soft Green

Rose

Aqua

Heather

## Neutral Shades

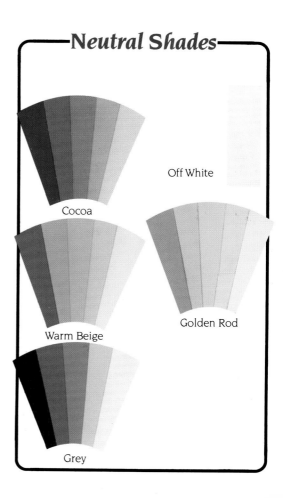

Cocoa

Off White

Warm Beige

Golden Rod

Grey

# High Noon ...

Pat Miller

Debbie Biggs

## Colorful Shades

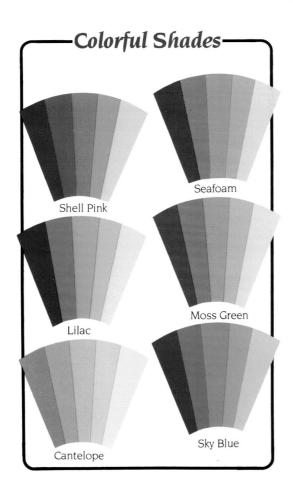

Shell Pink

Seafoam

Lilac

Moss Green

Cantelope

Sky Blue

## Neutral Shades

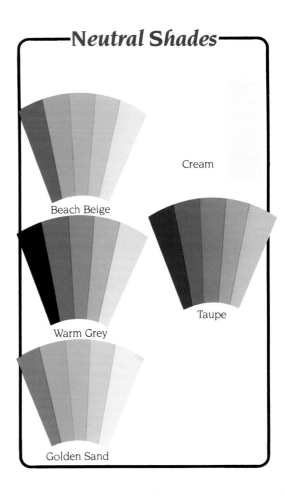

Cream

Beach Beige

Warm Grey

Taupe

Golden Sand

# *Afternoon ...*

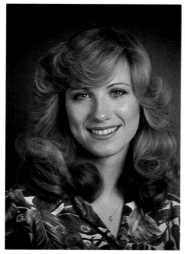

Elisa Douglas

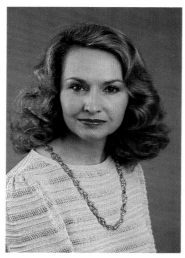

Gi Gi Griffin

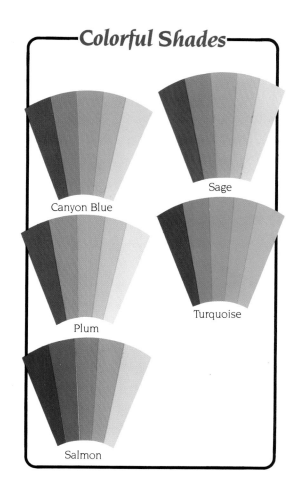

## *Colorful Shades*

Canyon Blue

Sage

Plum

Turquoise

Salmon

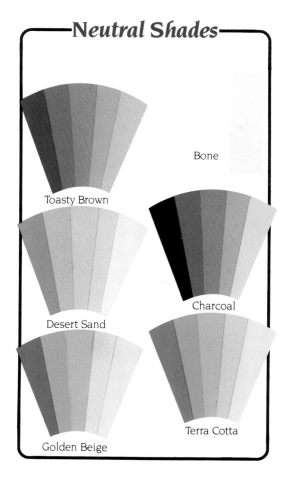

## *Neutral Shades*

Toasty Brown

Bone

Desert Sand

Charcoal

Golden Beige

Terra Cotta

# Sunset ...

Lavern Cordoza

Sherri Crumpler

## Colorful Shades

Teal

Olive

Mauve

Aqua

Brick

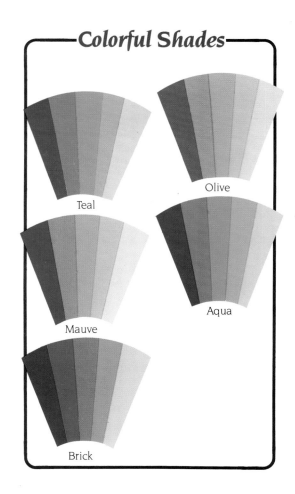

## Neutral Shades

Warm Brown

Vanilla

Amber

Smoke

Golden Beige

Rust

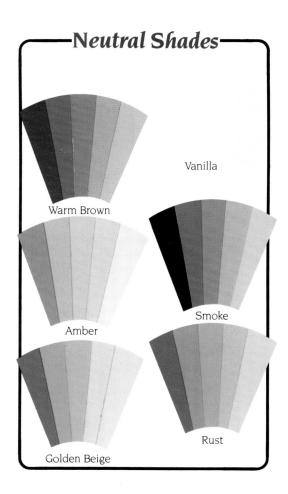

# Evening...

Vicki Giese

Emilie Barnes

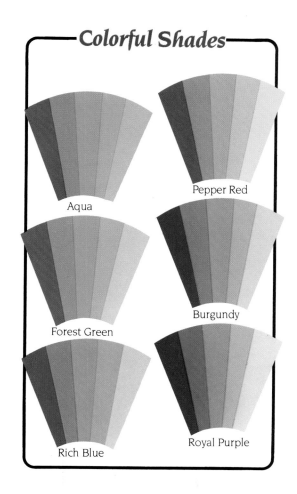

## Colorful Shades

Aqua

Pepper Red

Forest Green

Burgundy

Rich Blue

Royal Purple

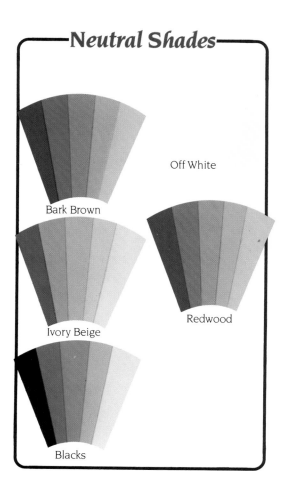

## Neutral Shades

Bark Brown

Off White

Ivory Beige

Redwood

Blacks

# Midnight...

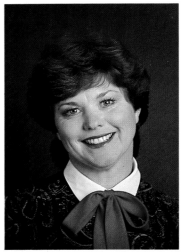

Sally Dunbar

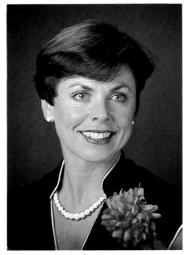

Nancy Wood

## Colorful Shades

Amethyst

Aquamarine

Ruby

Sapphire

Coral

Emerald

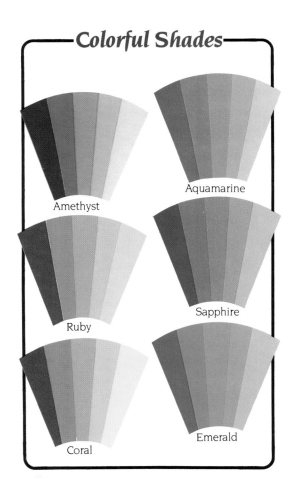

## Neutral Shades

Beige

Pearl

Onyx

Mink

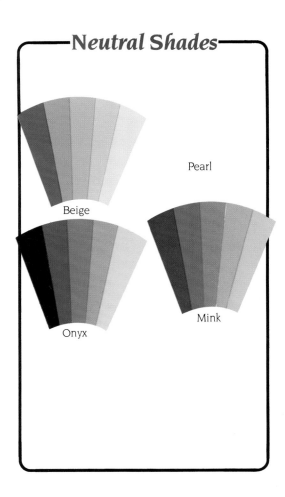

# 1
# Wave The Magic Wand

*"Be ye transformed"* (Romans 12:2)

Remember the story of Cinderella, a plain young girl locked in the house scrubbing for her stepmother? She had no fun and no future as she watched her stepsisters dancing off to the ball. Then one day a Fairy Godmother waved a magic wand and transformed Cinderella into a princess. Her rags turned to riches and she rode off on a pumpkin changed into a coach. Her shoes shifted to glass slippers and she was the belle of the ball.

Have you ever wished for a Fairy Godmother to transform you? Have you wanted to throw out all your clothes and start over? Have you been grasping for help and not knowing where to look?

Shades of Beauty is your Fairy Godmother. When you follow the guidelines presented, you will be quickly transformed from plain to pretty, from blah to beautiful, and from ordinary to extraordinary.

June Pica from West Allis, Wisconsin wrote me:

I was transformed when I began putting into practice the principles you taught me. My friends began to ask me what brand of makeup I'd been wearing. They said, "It's so attractive that it makes you glow!" I explained that I'm using a variety of brands—the secret is in wearing the right shades: MY COLORS! I also tell each one the role my correct colors play in my magical transformation from Blah to Ah.

As you seek your own Shades of Beauty, you will find simple, inexpensive secrets to transform your image. I can't guarantee that you will discover a Prince Charming or that your current prince will become even more charming, but if you follow all the suggestions in this book that apply to your look, you will see changes. When you stand before your mirror, you'll think you've been touched by a Fairy Godmother!

# Chapter 2

XXXXXXXXXXXXXXXXXXXXXXXXXXXXXXXXXXXXXXXXXX

# 2
# A Closetful of Clothes
# And Nothing To Wear?

*"Put on thy beautiful garments."* (Isaiah 52:1)

*S*o many women have closets, boxes, drawers, and garment bags of clothes and yet they never seem to have the right thing to wear. This is because they have never been taught how to plan a wardrobe around their own personal colors.

Until you know how to choose colors correctly, you may buy clothes for the wrong reasons. Women have told me:

—I bought a dress that looked great in the store window
  but never looked right on me.
—I buy the first thing I find because I'm always in a hurry, and
  that's the way I look: thrown together!
—Nothing in my closet matches!
—When I counted up, I had eighteen white shirts.
—I seem to have all flowered blouses and all plaid skirts.
  What a mess!
—It looked great on my girlfriend but just awful on me!
—I bought it on sale and it didn't go with anything I had.

XXXXXXXXXXXXXXXXXXXXXXXXXXXXXXXXXXXXXXXXXX

Do any of these sad statements sound like you? Do you purchase without a plan? Do you wish you had some simple guidelines for shopping?

*Shades of Beauty* will show you how to eliminate costly errors and how to build a winning wardrobe with clothes that will enhance your natural coloring.

In recent years there have been many formulas for color consultations. One school of thought divides everyone into two groups: warm and cool. Another puts everybody into four categories according to the seasons. At this very moment various color consultants, authors, and even fashion academies are scrapping over which one of them invented spring, summer, fall, and winter, failing to give credit to God, Who, in fact, created the signs and the seasons and the days and the years (Genesis 1:14), long before any of us appeared in living color.

In either the warm/cool or the seasons system, the colors are chosen in broad generalizations and make no allowances for those who fall somewhere in between.

In my personalized *Shades of Beauty* each of you is categorized in one of eight segments of the day, in harmony with the "Author and Finisher" of us all. As you examine the descriptions to find your own time on the clock, picture yourself in:

- The soft shadows of the approaching DAWN.
- The fresh, crisp vibrancy of a SUNRISE.
- The clear warmth of a new MORNING.
- The sun-washed hues of a HIGH NOON.
- The rich glow of an AFTERNOON.
- The romantic range of a glowing SUNSET.
- The fireside feeling of a cool EVENING.
- The stark contrast of a star-twinkling MIDNIGHT.

Does one of these scenes seem right for you? As you slip into your time slot, you'll come alive out of your closet confusion into the light of a new exciting day!

# Chapter 3

**3**

# My Time's Not Your Time

*"To every thing there is a season and a time to every purpose under the heaven."*
*(Ecclesiastes 3:1)*

*E*ach one of us is a unique person. Each one of us has an individual dual combination of hair color, eye glints, skin tones, as we have our own fingerprints. I would love to sit eye-to-eye with each one of you and choose the Shades of Beauty which would be the very best for you, but instead I will show you how to be your own color consultant.

As you read each of the eight chapters on the times of day, you will first find descriptions of the feelings of those moments. You may know instantly where you relate, but if not, focus on the eye colors, hair shades, and skin tones and find a time which comes closest to you. If you are doubtful about your coloring, ask your family or friends to help you. Looking·at the pictures and palettes of colors in the front of the book will also aid you in determining your time of day.

When you have chosen your time, look at your palette of colors and get a sense of how well they blend with each other. Read the section on your Shades of Beauty and then move on to the combinations.

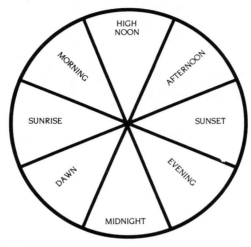

## SHADES OF BEAUTY

Many years ago I was color-analyzed by someone who handed me a group of "my colors" and then sent me off. I had no idea how to combine them or how to shop. So I've tried to show you clearly how to use your palette of colors.

In addition to your own shades and the correct combinations, I explain and provide pictures of the best prints, styles, fabrics, and accessories for you. With this information, you will be able to be your own color consultant and you can take your page of colors with you when shopping for your winning wardrobe.

Often women ask about their real hair color versus what they've done with it. Since God put us together in harmonizing shades, we will look the best somewhere near our own coloring. If you are too drab, you might frost your hair a little for highlights, or if you've always been blond and want to stay there, at least tone your hair so it doesn't look bleached. There is nothing worse in hair color than a brassy, artificial blond with black roots.

If you have changed your hair tone, have you destroyed your natural look? One bleached blond with brown eyes had been told by a color consultant she was a "spring" because she had blond hair. She had been told to wear bright blue, red, and green, and had not felt right in them. When I prepared her personal palette, I suggested she tone her hair with a beige rinse, which picked up the lightest brown in her eyes and gave her a warm, natural look instead of the harsh blond contrast. Her best colors were in the afternoon tones of soft peach, beige, and light green. She

looked radiant in her complimentary colors with her hair closer to her natural tone.

As you read *Shades of Beauty* you will begin to get a sense of the color and feeling at your time of day to guide you in your selection of clothing and cosmetics. Read each chapter, even if it is not your time of day, as your understanding of the whole concept will be enhanced and you will be able to pick up practical tips to apply in your new technicolor life!

# Chapter 4

# 4
# *Dawn*

*"Until the day break, and the shadows flee away . . ."* (Solomon 2:17)

## *T*he Feeling of DAWN

Have you ever been up in the morning before the sunrise? What a peaceful time! The world is still asleep and you feel very special to be a part of this scene. You sense the cool breeze and the clean feeling in the air. In these few precious moments when the east side of the sky is turning those luscious shades of pinks and plums, the scattered clouds are still edged with the blackness of night. The west side of the sky has not yet given way to the lighter colors and is a deep velvet blue with twinkling stars accentuating the darkness. Dawn has that special quality of combining contrast, softness, and coolness in one beautiful picture. Homer called this time of day "Rosy-fingered dawn" and Euripedes mused, "How oft the darkest hour of ill breaks brightest into dawn." Down through the centuries poets have looked to dawn as the quiet prelude to the advent of day.

Picture yourself as the day breaks and the shadows flee away. Place yourself on the top of a tall turret at the corner of a gray stone castle. As

you stand in the chill, the sky begins to lighten. Fog is still piled in fluffs below you on the dark lawn and just a hint of color touches the horizon. In your imagination the ghost of Hamlet appears dimly in the shadows of the battlements. As you strain to see his steel blue doublet in the dark, he states as from the past, "But look, the morn in russet mantle clad walks o'er the dew of yon high eastern hill."

Do you feel the mystery of dawn, its cool and shadowed look? Do you sense the soft contrast of approaching day? Do you revel in the romance of the rosy-fingered dawn?

## Identification of DAWN

You fit into the DAWN picture if your coloring has a natural soft contrast and cool look. As DAWN you have the privilege of using the romance and drama that comes with the early morn. DAWN's contrast comes from steel blue or hazel eyes and light creamy skin beneath the dark brown hair. Your softly contrasting coloring is the main thing that makes you a DAWN.

## Shades of DAWN

DAWN's look is created by using subtle colors such as peach, dusty aqua, steel blue, soft lavender, forest green, and dusty rose. Neutrals such as mink brown, the color of your hair, charcoal gray, ivory beige, winter white, and champagne will provide the background for your own Shades of Beauty.

## Color Combinations of DAWN

The romantic and dramatic effect that your contrasting coloring creates in you as an individual needs to be recreated in your clothing. Always use your colors in a light-dark combination. Monochromatic (shades of one color) looks will be very good for you. Try light and dark dusty rose. The color is correct for you and the combination is light-dark. The colorful shades play an important part of your image, and you should be sure that any combination of colors that you put together has a colorful shade in it and is not totally neutral.

A charcoal gray suit and silver gray blouse are light and dark, but as a combination it does not have enough color for you. There are several ways to add a colorful shade to a neutral outfit. You could wear a scarf with a silver and aqua print or you could replace the silver blouse with one in dusty rose. Either way the outfit now has both the color and the light-dark contrast that it needs to accentuate you the best.

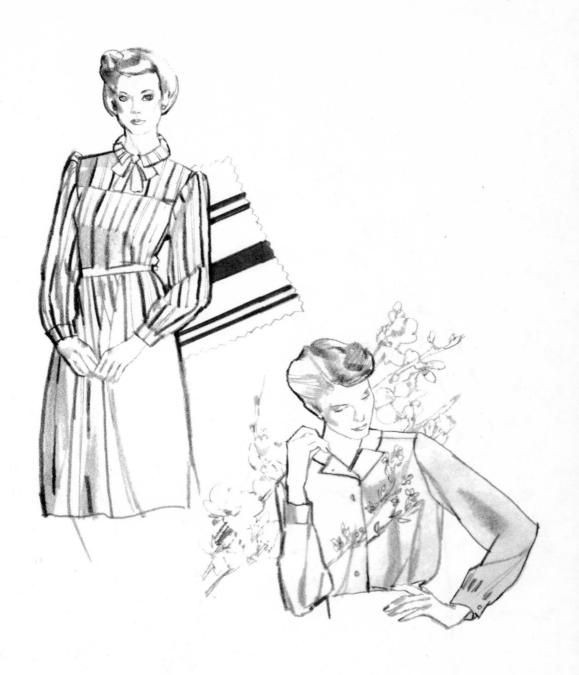

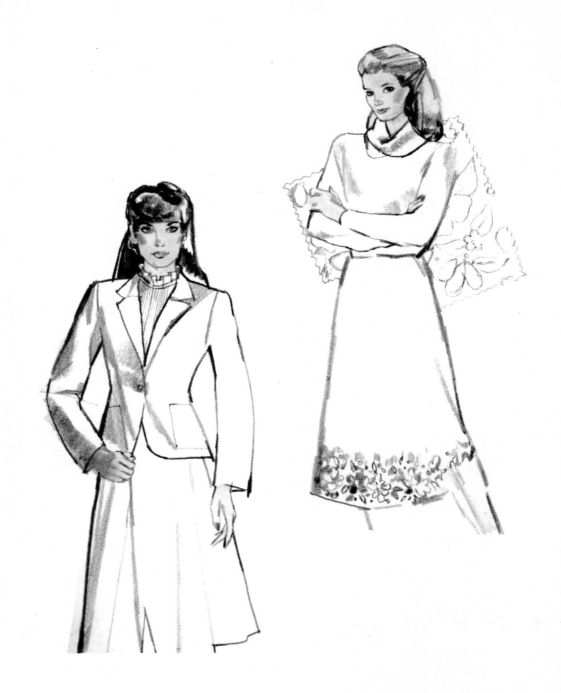

## Prints of DAWN

DAWN is beautiful. Don't ruin this feeling with cluttered or busy prints. Picture those dark clouds scattered against the pink sky or the fading stars sprinkled across the deep blue velvet horizon. Such scenes give you the key prints: those that are simple with spacious backgrounds. Use motifs such as flowers, cherry blossoms stretching gently across a blouse, or use muted stripings in light-dark such as steel blue, off-white and charcoal blending together in a vertically striped dress. Border prints or asymmetricals are also excellent. An off-white dress with a forest-green and rose floral pattern along the bottom is one example of a border print, and a long-stemmed red rose growing up one side of a blouse is asymmetrical, or one-sided. Print doesn't need to be in every outfit, but when you use it, be sure that it captures the simple beauty of DAWN.

## Styles of DAWN

Styles also play an important part in the mood of DAWN. You want to create the look of easy elegance without severity, simple lines without harshness. Even if you spend most of your time at home with the children, you should look and feel pretty. This easy elegance is created by using styles that are softly tailored, like slacks, skirts, blazers, blouses, shirtwaist or T-shirt type dresses with soft accents; bow blouses with full sleeves and small stand-up ruffle or lace on a collar or cuffs; flaired skirts, and, if your hips permit, pleated pants.

For the business atmosphere you could use an A-line skirt with a blazer in your dark steel blue, and a dusty rose pinstriped blouse with a ruffle on the collar and cuffs. This combination of steel blue and dusty rose is a striking color combination of light-dark with colorful shades. The pinstripe is a good print and the ruffle gives a soft accent to the style, creating an easy, elegant look.

Many dresses also have an elegant style. Slimming shirtwaists with a blouson top and a bow that ties on the side are especially appropriate in deep solid colors worn with pearls for the light-dark contrast. Dresses with an oriental accent are also good. The side closings and high collars accentuate your elegant look.

For that casual at-home feeling, dark slacks and a light T-shirt or sweater with a long silk-like scarf tied low on your chest in a men's tie knot will add the soft accent that you need. Cowl necklines give the easy drape especially effective for DAWN even in casual clothes. If you wear jeans be sure they don't look faded and sloppy. The best way to ensure that your jeans hold their shape is to dry clean them from the start. This keeps them from fading so quickly and gives them a good crease. This is not so

costly as it might seem. (You'll be amazed at how much dust a pair of dark unfaded jeans can absorb before they look dirty.) If for your life-style you feel comfortable in jeans, wear them, but put a blouse in the right print or style with them to give you the romance and drama of DAWN.

### Fabrics of DAWN

Another option you have in creating your look is to use touchy fabrics with a textured appearance, which adds to the irresistable romance of DAWN. These are fabrics that you and even your friends will want to feel. During cold weather use fabrics like velvet, velour, ultra-suede, wool crepe, cashmere, angora hair blends, and satin. For the cooler feeling you need during warm weather use fabrics that are lightweight: raw silk, nubby linen, Qiana, crepe de chine, chiffon, voile, lace, and open-weave fabrics.

In your shopping you may find a fabric that seems to be touchy to you but is not on this list. That is acceptable as long as the material has a pleasing feel and is not bulky. Tweed, for example, may at first seem to be touchy, but as you think about it, it is too coarse for comfort. Tweed has a rough texture; therefore, tweed would not be right for your romantic look.

Right now you might be thinking that trying to find all of these things in one outfit will be like trying to find a needle in a haystack! You're right; it is not easy to get every single aspect of your look all together at one time. Don't be discouraged. You do not need to have every part perfect in every outfit, but you should begin to build toward your DAWN image while allowing yourself individual taste and style. We are creating a whole look that is right for DAWN.

First, and most importantly, is to use your colors, the soft subtle shades of DAWN. Second, but equally important, is the color combination—the way you use your colors in a light-dark contrast, always remembering to have some colorful shades.

The prints, styles, and fabrics all go to complete DAWN's romantic drama. When you use the correct *color* and the correct *combination*, you only need to use *one* of the last three ingredients:

    A. The right *Print*
    B. The right *Style*
    C. The right *Fabric*

This rule is very important to remember, for if you worry about finding all three things in one outfit, you will feel as if you're looking for that needle in the haystack. Be sure you find the print OR the style OR the fabric and then when that great day

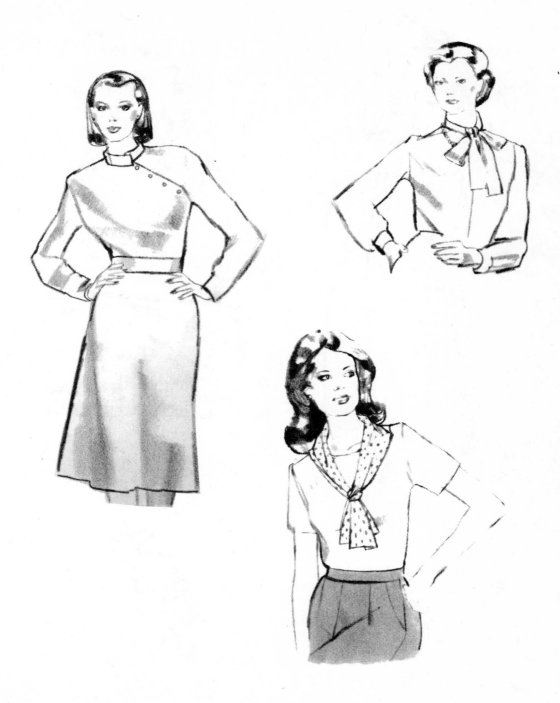

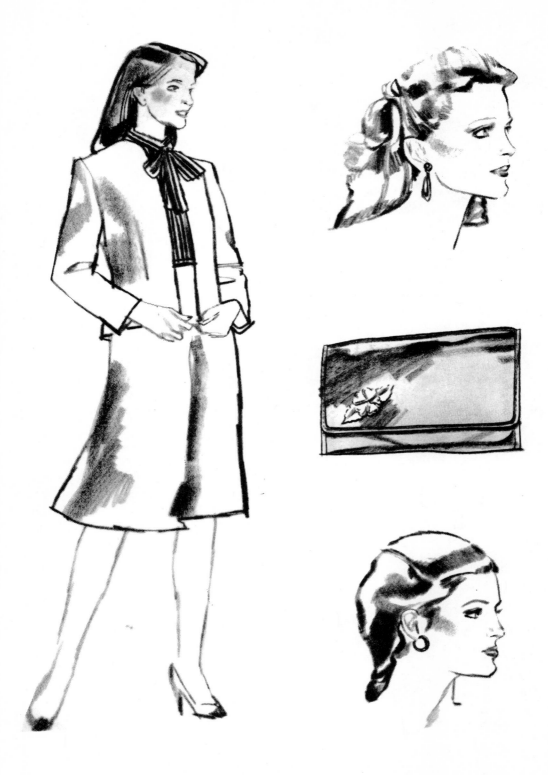

comes when you discover all three in one ensemble, you will really rejoice!

Also for a home casual style you may want the wash and wear of polyester. Remember, you don't have to use everything at once. A pair of mink brown gabardine slacks to match your hair, with a simple floral print blouse in mink brown, coral, and off-white would be perfect for you. This simple outfit has the correct *color* and color *combination* plus the right *print* to compliment you. The style may not be exceptional and the fabric isn't especially touchy, but the overall look is the soft contrast of DAWN.

## Perfect Outfit of DAWN

For your DAWN look, a perfect dressy outfit would be a forest green velvet blazer and skirt, with a seafoam and forest green striped blouse that has a bow at the neck. Let's evaluate this ensemble. First, it is your *color*. Second, it is the correct light-dark color *combination*. The blouse has a muted stripe, so the *print* is right. The bow makes the *style* softly tailored, and velvet is one of your DAWN *fabrics*—a perfect outfit!

## Accessories of DAWN

As you build toward your winning wardrobe, remember to *always* use your *colors*, your correct color *combination*, and *either* the right *print*, *style*, or *fabric*. As you follow this pattern, choosing accessories will become much easier.

The cool contrast of DAWN lends itself well to silver jewelry and pearls. Simple silver chains and pendants are the perfect accent to DAWN's romantic drama, and pearls can always be used with dark clothes to add the light contrast. Drop-style earrings are effective, especially in a teardrop shape. Hoop earrings are another option, but if you have a small frame, don't let them overpower you by being too large, too wide, or too distracting. If you are not comfortable in jewelry, scarves are excellent accessories. A long scarf can be tied in a bow beneath the collar of a blouse to give a tailored outfit a soft accent, or a figured scarf can be used to add the print to your DAWN image.

Shoes need to be simple and have a light appearance. An open-toed pump with a bow, an ankle strap style, or strappy sandals are appropriate. All your shoes should have high, thin heels in plastic or leather, rather than heavy wooden heels. If you are too tall for high heels or feel wobbly on thin ones, at least try to avoid low klunky looking heels and use ones as thin as possible. Boots that are supple leather or a soft suede in a smooth, tailored style will fit your feeling. Everyday casual shoes such as slides, espadrilles, and loafers are also acceptable.

Purses should fit in with your softly tailored styles; an envelope with a flower, a slightly gathered clutch, or a linen rectangle with dark trim would all work well with the look of DAWN.

Whatever your lifestyle or your budget, you can use the following guidelines to build your wardrobe and achieve the romance and drama in every outfit you put together.

REMEMBER:
1. Always use your *soft, cool colors.*
2. Always use a *light-dark* contrast *combination* with *colorful shades.*
3. In every outfit use:
   a. The correct *print,*
   > OR
   b. The correct *style,*
   > OR
   c. The correct *fabric.*

THREE OUT OF FIVE
KEEPS THE OUTFIT ALIVE

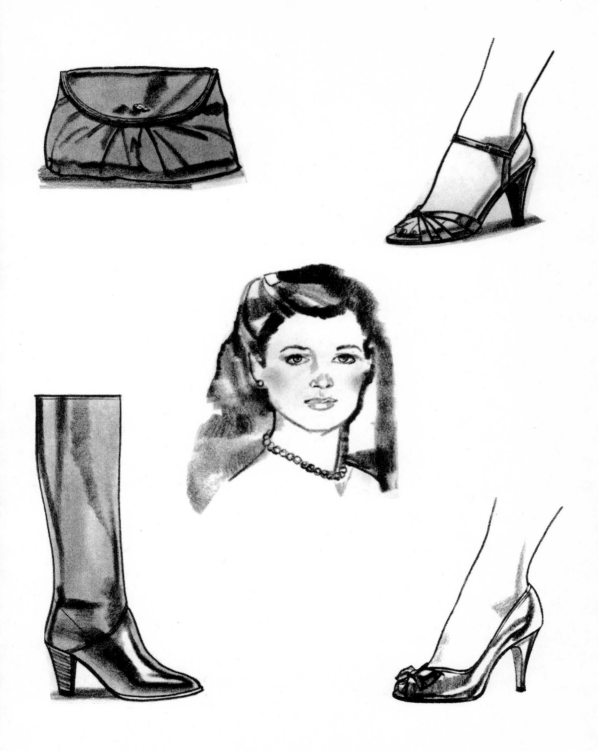

# Chapter 5

# 5
# *Sunrise*

*"The sun also riseth and the sun goeth down and hastens to his place where he arose."*
(Ecclesiastes 1:5)

## The Feeling of SUNRISE

Picture yourself standing on a hilltop for the Easter sunrise service. The sun is peeking over the horizon and the moisture of the dew glistening on the green grass touches your toes. Sleepy flowers perk up in search of warm rays and the sky is filling with vibrant hues of pink and blue. Quietly the people gather on the hill to the soft music of the chirping birds. As you take a deep breath, the air is fresh and the whole world is crisp, clean, and clear.

Each lady is attired in her Easter outfit in spring shades of pinks and blues to match the morning sky and hats are holding halos of bright blossoms. Pots of Easter lilies and hydrangeas point the way to the cross silhouetted against the ever-changing sky.

As you imagine yourself in this setting you can grasp the vibrant colors of sunrise.

### Identification of SUNRISE

The brilliant light of SUNRISE might overpower some people, but those of you with this matching crisp coloring will blossom when you use the fresh shades of SUNRISE. If you have clear blue, deep sapphire, bright aqua, or true green eyes, you have SUNRISE coloring. You, no doubt, have translucent toned peaches-and-cream skin, very blond or, occasionally, red hair. A SUNRISE could have very brown eyes and white blond hair (usually not natural) or silver gray hair with translucent white skin and blue or aqua eyes. Both of these combinations are rare. If you fit in this category you have found your place in SUNRISE!

### Shades of SUNRISE

For those of you striking SUNRISE women, wear colors that fit your time of day: cheery cherry, grass green, bright blueberry, coral, raspberry, and azure blue-green. When you learn to dress in your exact eye color, you will be even more eye-catching. Your neutrals should be sand, eggshell, charcoal gray, lemon yellow, and mocha.

### Color Combinations of SUNRISE

To create the fresh feeling of SUNRISE, use these colors in the natural combination of the early morn: different hues of blue, shades of morning reds, varieties of aquas. Picture one of your best colors and work with it. Neutrals should be used only when they are in combination with colorful shades. An entire gray dress on a SUNRISE would be a waste. To use gray at all you should add an aqua blue-green print or a cherry pink bluse. Since gray by itself is a neutral, add the pink or the blue and the outfit has color. If you are a SUNRISE and have neutral clothes, begin to brighten them with vibrant accents.

It is also important for the SUNRISE look to be made up of medium intensity shades, the middle colors on your chart, neither too light or too dark. In the cool weather of winter you may want to lean toward the darker colors, but if you do, use them in combinations with your medium shades.

Summer weather makes light colors attractive, but don't go too pale. You will be excellent in eggshell plus any medium colorful shade: eggshell with peach, or with azure, or with cherry. Always aim for a combination that has the fresh, crisp feeling typical of SUNRISE.

Monochromatic combinations are another way to use your colors: a dress in tones of your eye color, or shades of peach, or a suit in your darker green with a medium green blouse. Don't use all beige or all of any neutral. Remember, as a SUNRISE you

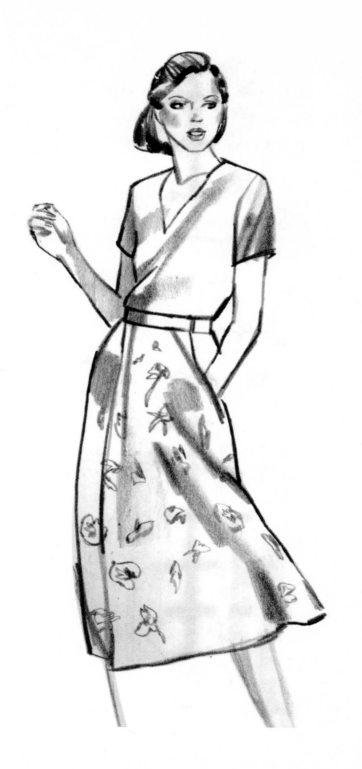

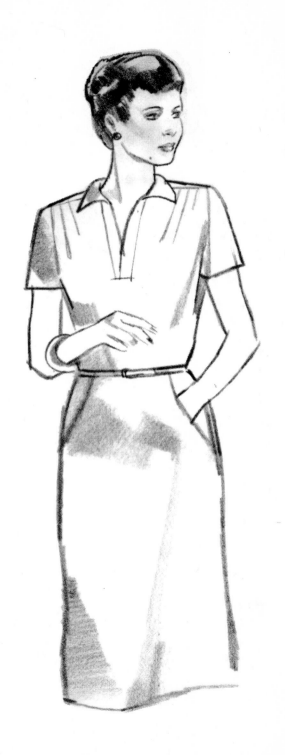

will always want to be colorful!

## Prints of SUNRISE

Solid colors are smashing on a SUNRISE, but the correct prints will also give you the crisp feeling you need. Simple, uncluttered prints that have a lot of background are the best. Flowers are a good choice. Think of the early time of day as flowers reach up to the sun, stretching to find the first rays.

Picture rows of tulips or daffodils, lean lines of long-stemmed roses, or clusters of lily of the valley, all florals set apart from each other by spacious background. The SUNRISE will grow with her flowers when they are set in border prints along the hem or climbing up the front of the dress.

Stripes and plaids may be striking as long as they are definite. As a SUNRISE you don't want anything that is muted or dull, but crisp and clean. You could use your prints in a flowered wrap skirt worn with a solid blouse in your eye color. You may use a whole print dress as long as it is not cluttered looking, or a splash of color on a scarf with a shirtwaist dress will give just enough print to accentuate the clarity of your SUNRISE shades.

## Styles of SUNRISE

The crisp, bright, fresh feeling of SUNRISE should be carried out in your style also. Clean lines will work well for your SUNRISE look, such as: tunic and shirtwaist dresses, simple jackets over the dresses, straight slacks with a colorful shirt, or blazers over A-line or pleated skirts. For the SUNRISE the skirts that have one pleat down the center front or the asymmetrical types with several pleats on one side of the skirt give a little more class. Vests are another clean-line type of style that will accent your skirts and slacks. Some of the classic co-ed influences of crew-neck and V-neck sweaters are excellent for you to incorporate with casual clothes such as jeans and simple plaid or print blouses.

As a SUNRISE woman you need never be bored for you can use your style to create a variety of different looks. In a business atmosphere clean-lined, crisp styles will work well. For example, an asymmetrically pleated skirt and matching blazer worn with a simple print tailored blouse will gain respect for you in almost any work situation and will add to your successful image.

A shirtwaist dress in a solid color such as raspberry with a string of white pearls as an accent, or with a flowered print scarf is perfect for a more casual California-type work atmosphere, daytime meeting, or luncheon.

## Fabrics of SUNRISE

The freshness of SUNRISE can also be created by using the correct fabrics, those that are smooth and crisp. For a SUNRISE, bulky fabrics such as tweeds or cable knits are too heavy and you should avoid rough or wrinkly cloth. Wool gabardine, sweater knits, and fine cashmere are appropriate fabrics for you. In the winter you will want to use velvet, velour, satin, wool gabardine, and tightly woven knits.

In the summertime use lightweight fabrics with a crisp touch such as poplin, linen, silk, sail cloth, seersucker, and cotton shirting. These fabrics all have the clean feeling that will accentuate your fresh SUNRISE look.

Remember, you should never be droopy or dull!

## Perfect Outfit of SUNRISE

How exciting it is to know you can now dress correctly. Once you get the feel of SUNRISE and use your own colors, your shopping will be so much simpler. You may actually purchase less, but you will know that everything you do select is right for you!

The key thing for you as a SUNRISE to remember is to use your clear colors and minimize the neutrals. Secondly, make sure every ensemble you put together has the correct color combination for you; every outfit must have a colorful shade and be of primarily medium intensity.

Once you understand these two basics you can play around with the print, style, and fabric. You may range up and down the monochromatic scale, but don't aim for a look of contrast.

A perfect spring suit for you would be a crisp linen in your eye color with a lighter shade silk shirt. A perky print handkerchief peeking out of the pocket would give enough accent. For a dressier occasion you could replace the hanky with a chiffon rose in a variety of your blue shades. This ensemble is in your best color, with a monochromatic blending of blues. The style and fabric are clean and correct, and the dot of print or the rose is complimentary.

If you are a SUNRISE and your life-style right now is more with diapers and dishes, use a clean pair of off-white jeans or slacks. When you don't need the sweater, knot the sleeves around your shoulders for a classic style. Although this outfit is casual and comfortable, its fresh, crisp look is perfect for you; it has the right *colors*, the right *print*, and the right *style*.

While you only need one of the last three things to be correct, the more of them you have, the better the outfit is. You still have room to develop your own individual

taste and style. Suppose you love the feminine touch of lace and ruffles, but know this is not your basic style; get one chiffon blouse to wear with your linen suit. Be sure the color is right and enjoy the variety. Remember, you only need to have one of the last three correct to make the outfit work for you.

## Accessories of SUNRISE

When you use these basic guidelines, the entire look of SUNRISE will fall into place for you and accessories will be an important part of your look. They must not be cluttered or overpowering. Simple gold chains will add a rich touch. Colored beads such as real or imitation gem stones, coral, jade, lapis, or aquamarine will highlight your image. These beads can be used to add color to a white or beige dress, or they can be used to accentuate a small portion of color in a print. Bright button earrings or bangle bracelets are also effective ways to add polish to your outfit. Smooth leather or leather-like belts in your colors will give you a fresher look than a matching self-belt.

Another creative choice to add a splash of color to your outfits is to use a silk flower, as with the blue linen suit. It might be pinned on a blazer lapel or used at the waist of a dress.

Shoes and purses are all easy to select when you are using your guidelines correctly. With a tunic style dress in your coral, a medium sand belt and pearls will be perfect. Add a medium sand pair of sandals with uncluttered wide straps and carry a pearlized patent bag. You want shoes that are not busy or bulky. Clogs, boots, or strappy sandals are too much for your simple style. Espadrilles go well with your casual clothes and come in many of your colors. For formal occasions still keep your shoes in trim lines. Classic pumps or dressy sandals with wide straps and high, thin heels are the best.

Purses need to be simple, clean and rectangular, such as envelope or clutch styles. If the business atmosphere requires more of a briefcase type of purse, keep it slim and smooth and it will be perfect for you. Don't use bulgy bags with pockets and clutter. All these accessories will combine to create the crisp, fresh feeling of SUNRISE.

Be sure every outfit you put together has your look. Follow these guidelines and you will always look sharp:

REMEMBER:

1. Always use your *clear colors*.
2. Always use *colorful combinations* in predominantly *medium intensities*.
3. In every outfit use:
   a. The correct *print*,
      OR
   b. The correct *style*,
      OR
   c. The correct *fabric*.

THREE OUT OF FIVE
KEEPS THE OUTFIT ALIVE

# Chapter 6

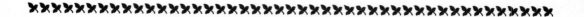

# 6
# Morning

*"Who is she that looketh forth as the morning, fair as the moon, clear as the sun?"*
(Solomon 6:10)

## The Feeling of MORNING

Morning is breaking, fair as the moon, clear as the sun. Morning is a time of action when the world of people starts moving and the warmth of the new sun heats the day. Morning is a transition time between the crisp, clear brightness of the SUNRISE and the gentle muted softness of HIGH NOON. Morning is a time of beginnings, a fresh start. The colors are not so bright as the SUNRISE yet not so sun-washed as HIGH NOON. It's not too hot or too cold; it's a time of rare perfection.

You're standing in the mountains with the fresh breezes blowing your soft hair and the perfume of the lilacs exhilerating every breath. The sky is clear blue with occasional white clouds and the fields are soft green with dots of goldenrod. There's heather on the hill and it's cherry pink and apple blossom time. The chalets have white window boxes newly filled with geraniums although the mountains are still capped with snow. New streams bubble by clear as aquamarines, and blue jays call their friends back from

the south. As you listen, the hills come alive with the sound of music. God is in His heaven; all's right with the world.

### Identification of MORNING

To be a MORNING you should have a fresh, clear vibrancy about you, a love for life, a colorful vitality. Your eyes may be like sapphires or aquamarines, and they may have touches of jade or flecks of topaz. Your hair won't be as blond as the SUNRISE or as sun washed as HIGH NOON. It will be in the middle range of blondes, reddish blondes, or, in the case of my mother and me, just plain field-mouse brown. (If your hair falls into this non-descript category, perhaps you might consider having it frosted or woven to give highlights to your halo. Don't do any drastic bleaching but lighten up your life to match the morning.) Your skin is clear, light creamy, often translucent, and fresh as the morning dew.

### Shades of MORNING

For those of you with the fresh softness of the MORNING, color is most important and you must use it generously but wisely. You don't want to look like a carnival banner, but if you stay in neutrals you will fade away. Your fresh blue or aqua eye color will always be the best for you, as it is your most vibrant natural color. The pink in your skin will be a flattering shade to use whether it is rosy or coral. Soft greens, heather, or geranium will compliment your coloring. Neutrals such as cocoa, goldenrod, warm beige, creamy off-white, and gray should be used in moderation.

### Color Combinations of MORNING

Color is so important for the MORNING look and the shades should be neither too bright nor too light. The medium range of color blending into the light direction will enhance the MORNING and give the fresh dew feeling so vital to this time of day.

There are several different ways to combine your colors. You can use all medium tones: geranium with silver gray, soft green with cocoa. Or you can try all lighter shades for summer: off white with rose pink, aqua with pale aqua, fresh blue with beige. You can also work with medium to light contrast: geranium and off-white, blue and light goldenrod, aqua and beige. One of the most effective combinations for the MORNING is different shades of one color starting in the medium range and getting lighter: degrees of blue, aquas, reds and heathers.

One caution is to avoid large amounts of neutrals and to complement each neutral with a splash of your best colors. If you feel you need a conservative suit and you

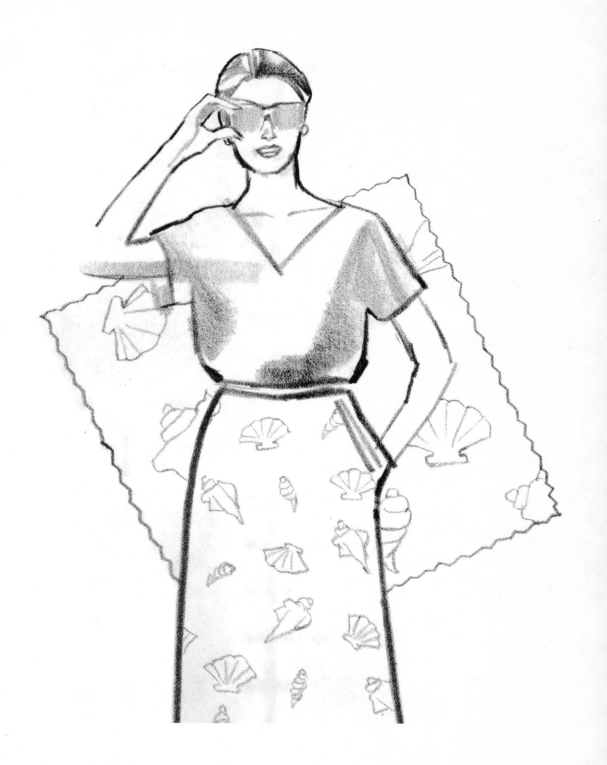

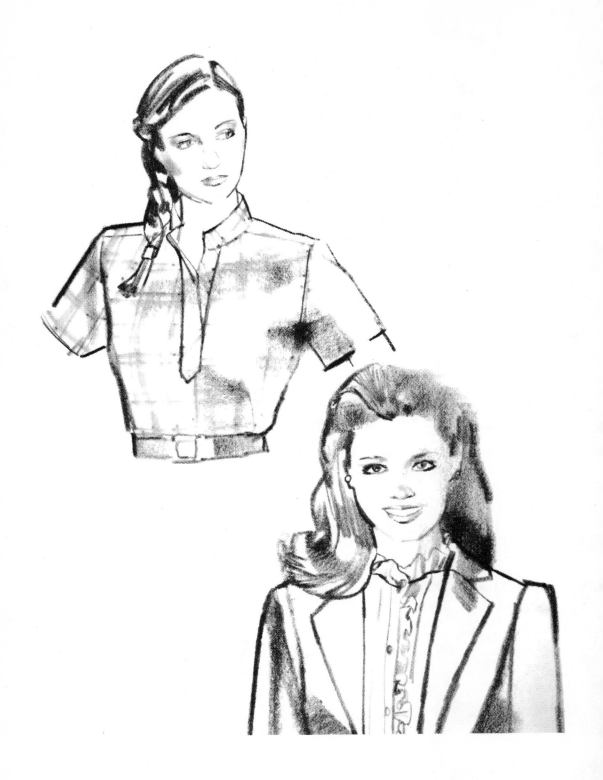

choose a medium cocoa, don't add an off-white blouse. Instead, find a print that picks up the cocoa and adds one or two of your colors. If you have a beige dress in your closet and it fits well, add a scarf with roses and soft green leaves or a jacket with stripes of beige, aqua, and off-white. Either touch will redeem a bland beige dress and make it lively enough for you. Similarly, if you live in a northern climate and have always felt a basic black suit was a necessity, be sure to add generous quantities of color to save the suit. In the future, use your medium shades to form your basic wardrobe.

## Prints of MORNING

Since the MORNING feeling is fresh, soft, and colorful, your prints should follow the feeling. They should be simple, subtle, uncluttered; they should have obvious background like the sky with few clouds or the fields with a few daisies. The MORNING prints should fall between the crisp bright SUNRISE and the muted tones of HIGH NOON. They should be blended and never stark, harsh, or bold. There are endless varieties of floral prints on spacious background in every color. Clouds and shell prints may be found in the summer and colorful plaids and paisleys are available in the fall and winter. The spring will be the best time for you to shop, as the prints will be appropriate and your colors will be plentiful.

## Styles of MORNING

Softly tailored clothes are the best for the MORNING look. The classics such as blazers, A-line skirts, tailored shirts and straight slacks are perfect for the basic MORNING style, but in order not to appear too severe they need soft touches. The blazer needs a print scarf or a chiffon rose. The A-line skirt needs a soft bowed blouse with full sleeves. The tailored shirts need to be of silk-like fabrics and the straight slacks need a blouson top in a soft color.

The softly tailored look fits well in a business atmosphere, but the softness reminds the others that you are a woman. You do not need to have cascades of chiffon ruffles or frou-frou to be feminine. A blazer and A-line skirt with a small self-ruffle on the collar of the shirt and perhaps a grosgrain ribbon at the neck will provide a soft touch for a tailored look. One lady in Fresno bought inexpensive plaid blouses in her colors and stitched lace around the collars and cuffs. Your clothes don't need to cost a lot to be effective.

For casual looks the wrap-around print or denim skirt with scoop necked T-shirts

gives a fresh feel and the simple shirtwaist dress can be trimmed up or down for all occasions.

MORNING women love to be glamorous and my mother calls her look "simple elegance." She wants clothes that are in uncluttered good taste, but which have some detailing about them that lift them above the ordinary. She has an off-white linen suit which is a classic but has rows of stitching on the roll collar. The right front crosses over the left and buttons at the waist where the collar ends. The linen fabric is right for her, the style is softly tailored, but few details give it a "simple elegance." She has two different blouses which both go well with the suit. One is a soft rose satin with scattered white flowers. It is simply tailored and has a roll collar with a soft bow. The other is turquoise chiffon. It has a double-ruffled collar and cuffs made up of tiny accordian pleats. Each blouse is soft and simply elegant.

### Fabrics of MORNING

To achieve the fresh softness of morning, fabrics with feeling are the best, those that you love to touch: silk and silk-like fabrics, raw silk, nubby linen, Qiana, crepe de chine, georgette, voile, natural cottons, seersucker, terrycloth and lace. In cooler weather try: velvet, velour, corduroy, ultra suede, cashmere, wool crepe and tightly woven knits. Remember that soft texture is what you want and you should avoid bulky looks and stiff, severe fabrics.

### Perfect Outfit of MORNING

Before purchasing a perfect outfit ask yourself: What are my best colors? What is my combination pattern? What prints are right? What is my style? and What kind of fabric is flattering? The first two questions are the most important, and if you have one or two of the last answered correctly the ensemble will play.

Let's pretend you walk into a store and spot a soft sea green and off-white striped seersucker shirtwaist dress with small self-ruffles on the collar and cuffs. You run through your mental checklist. Are medium green and off-white your colors? Yes. The combination has color and is medium-light, both perfect for the MORNING. Does this dress have either the right print, style or fabric? Muted stripes are an acceptable print, the style is softly tailored, and the fabric has texture. The results are a simple classic dress that fulfills your requirements. If you wish to add more of a business look, buy an off-white linen jacket which will not only blend with this dress but will become your basic spring into summer blazer.

For your perfect casual look, you will be best in nubby linen-like slacks with

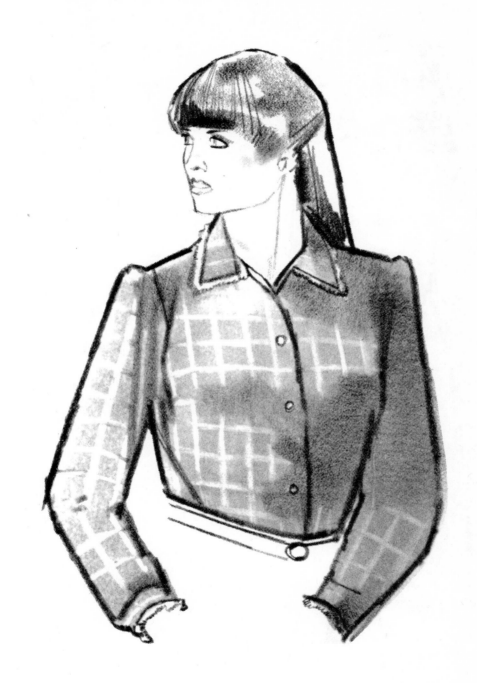

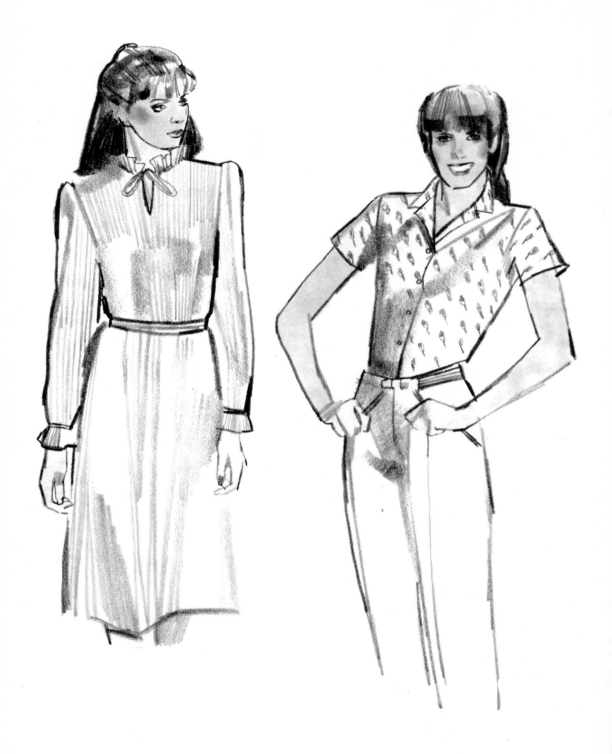

perhaps slanted front pockets for detail. Print blouses in the MORNING florals are readily available in at least spring and summer and usually throughout the year. In building a wardrobe, always be searching for your perfect ensemble, and when you find the right combination of requirements, buy as much of it as you can.

Recently my mother and I were shopping in Phoenix. We both hit winners on one evening. I saw linen separates in my perfect eye color. Since it's not every day that the manufacturers choose to key their whole line to my eyes, I had to take advantage of this great moment. I bought the blue linen blazer, split-skirt, and pants, all in the right color, style, and fabric. I added a floral print blouse, and a striped T-shirt to give the right color combination and medium-light intensity.

In the next department I found a silk middy blouse in the same blue with a big off-white collar and a pair of off-white silk knickers. While knickers may be a passing fad, they added a note of variety to my ensemble.

The shoe department had matching blue low lacey sandals and I was excited over how quickly I had bought my spring into summer basic wardrobe. Since I have many other blouses with my eye color in them I will be able to expand this outfit into many more combinations.

As I was making my selections in blue, my mother found a sale rack of Evan Picone cocoa linen pieces. She bought a short cropped jacket with gathered sleeves and pearl buttons, a flared full skirt, and softly tailored slacks. To go with these she found a cocoa silk blouse with three geranium blossoms placed on an open background giving the color she needed for an accent. Her ensemble is her neutral cocoa with her geranium red. The combination is medium, the print colorful and spacious, the style simple elegance, and the fabrics textured linen and silk. A perfect ensemble. She also bought a cocoa blouse with no print but a double Peter Pan collar and bow which she wears with the skirt or slacks and a soft green, cocoa and white plaid blazer she already had.

When we got home we found several other print blouses and some shoes to coordinate with the three linen pieces, and she now has an expanding basic wardrobe in the *right colors*, the *correct combination* and with appropriate *prints*, *style*, and *fabric*.

Building your wardrobe can become an exciting part of life when you grasp the importance of planning for your own Shades of Beauty.

## Accessories of MORNING

Now that you have a clear view of how to select your clothes, you will want some guidelines on your accessories. Bearing in mind the principles of simple elegance

and moderation, you will not want to clutter yourself up or go to extremes. A single strand of opera length pearls will give you the basic jewelry you need and you can later add strings of beads in your medium colors, such as coral, jade, and turquoise. Gold chains give class to dressy outfits and single silk flowers in matching shades will add a touch of elegance to a simple suit. If your hair has gold highlights, build your jewelry collection in gold, but if you have silver tones, the use of white gold or silver will be more effective.

As for shoes, again think "simple elegance." You don't want klunky, faddish feet. Your aim is for whatever shoe will blend the best with your shoftly tailored clothes. The classic pump is always appropriate and it is now available with open-toes for variety. The pump comes in many colors and you should look for one that matches the basic wardrobe you are building. A sling-back sandal will be best for a dressy shoe, and for more formal occasions you will enjoy the strappy sandal in gold, bronze, or pewter. To go with your slacks, espadrilles are always neat, and ballerina slippers in bright colors are always fashionable.

Your handbags should be of smooth leather, suede, or metallics, and should be as your clothing: softly tailored. I've recently found simple envelope clutches with a matching bow on one corner—a perfect bag for a MORNING! In the summer straw baskets with silk flowers clustered on top provide the soft floral MORNING touch. REMEMBER:

1. Always use your *soft, fresh colors.*
2. Always use *colorful shades* in *medium to light intensities.*
3. In every outfit use:
   a. The correct *print,*
      OR
   b. The correct *style,*
      OR
   c. The correct *fabric.*

THREE OUT OF FIVE
KEEPS THE OUTFIT ALIVE

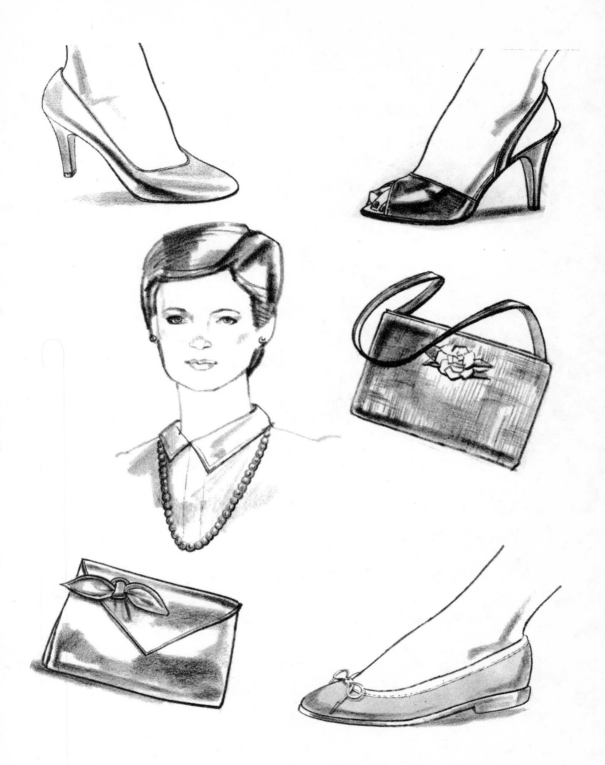

# Chapter 7

# 7
# High Noon

*"I have seen all the works that are done under the sun."*
(Ecclesiastes 1:14)

## The Feeling of HIGH NOON

Noon is the time when the sun is at its highest and casting a soft white peaceful light upon the earth. The sky is pale blue and gentle breezes surround you. Think of being at the beach, standing on the bluffs overlooking the ocean. You see sailboats bobbing up and down on the water, and sea gulls soaring past puffy white clouds. The sun glistens in your hair and bathes you with its warmth. The feeling is gentle and soft, like the sunwashed colors of the beach. A quick summer rain shower comes and goes. As you look over the waves, you see a rainbow on the horizon reflecting those pastel shades so perfect for the HIGH NOON.

Some people might look faded in these muted colors, but the HIGH NOON woman takes on an ethereal glow when clothed in these soft, subtle shades of the rainbow.

### Identification of HIGH NOON

The HIGH NOON woman's coloring is delicate with eyes of moss green, hazel or soft blue. She usually has light brown hair that bleaches easily in the sun. Frosted hair or gray hair with a pearly tone also fits into the HIGH NOON feelings. Skin colors are pale, light golden, ivory, fair, or freckled. The pink in her skin is a soft shell pink rather than a bright cherry pink. The HIGH NOON girl usually has soft features such as rounded cheeks, a turned-up nose, and full lips, adding to her gentle look.

### Shades of HIGH NOON

As a HIGH NOON you should be very careful that your colors are not so strong that they overshadow the real you. This problem is accentuated if you have gray hair. Many times as you get older and you feel your coloring is fading, people will tell you to use loud colors to liven you up. Unfortunately, this choice has the opposite effect, and wipes you out. A strong purple on a pale lady is overwhelming. The dress has color but you have none. Don't let heavy color and large prints cause you to lose yourself in your clothes.

To make the most of your natural beauty, use the shades of nature: seafoam, moss green, shell pink, sky blue, lilac, and cantaloupe. Picture yourself wrapped in a rainbow. As a HIGH NOON, you can also use neutrals such as golden sand, cream, beach beige, warm gray, and taupe, but no harsh tones for you! HIGH NOON is soft, gentle, breezy, light. You always want color to surround you, but your shades should be sunwashed. A dress of all beige may go nicely with your hair and skin, but as an entire outfit it will be too drab for you. Add a scarf of your eye color, or of your skin pink to give it life. The colorful shade provides the warmth you need.

### Color Combinations of HIGH NOON

How should the HIGH NOON combine her rainbow colors and her neutrals? Of all times of day, HIGH NOON is the best in soft and floral prints. Although SUNRISE should use flowers standing straight, HIGH NOON should have the feel of fullness, like flowers that have opened in the heat of the day. All tones should blend together and there should be little visible background or contrast.

Shell pink and seafoam green in a floral print on a creamy background has the softness of HIGH NOON. A cantaloupe and cream combination is as inviting as a "50-50" ice cream bar. Multicolored blends of beige, lilac, and blue or perhaps pink, taupe, and brown all play up your soft gentle life.

As you look at your spectrum of colors, realize that the medium to lighter shades

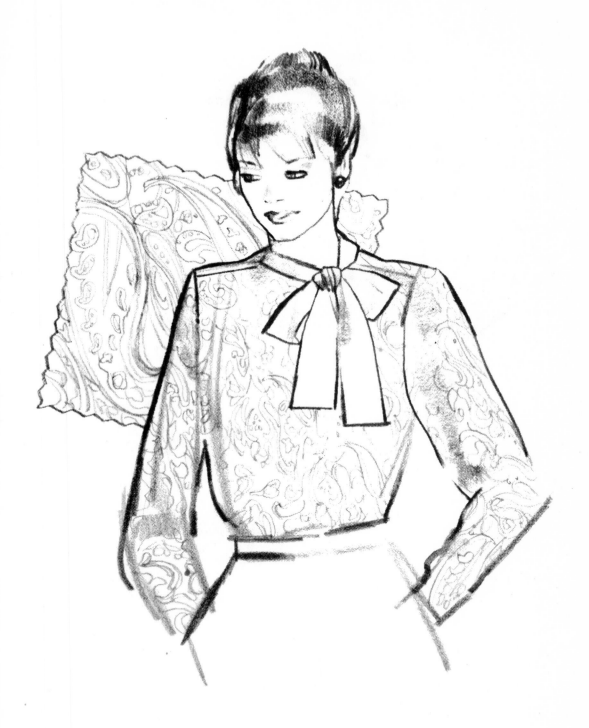

will always be the best for you. This does not limit you to the lighter shades forever, but they will do the most for you. In the winter, when you feel that you must use a darker shade, accent it with a medium tone. You might find a luscious velvet blazer in your dark seafoam green. If you put a white blouse with it, the outfit would have a light-dark contrast which is too harsh for your HIGH NOON softness. Instead, add a blouse in your medium green or wear a print with medium and dark green leaves and some pink flowers. The medium tones will lighten and soften the more severe dark shades. Overall, the effect will be softly colorful without the dark-light contrast that is too much for you.

No longer do you have to wear dark colors in the winter, as current pastel-colored wools and light knits are available for the HIGH NOON woman all year round. Remember, HIGH NOON is not black-white, but sun-washed, muted, and soft.

## Prints of HIGH NOON

Prints are most important for HIGH NOON as they unite the soft rainbow colors with the muted touch of flowers, the open look of summer blooms. As a watercolor blends its shades together with no harsh edges, so should prints that capture the softness of the HIGH NOON melt together. You can choose flowers, stripes, or plaids as long as they are softly blended, but avoid bold or distinctly defined patterns. Prints should be medium in size because large prints will be too overpowering and small close calicos are too cutesy for the subtle feeling of HIGH NOON. The soft expressive paisley is an excellent print for you, and it usually comes in your Shades of Beauty and in a medium size. Seashells, clouds, and rainbows are other HIGH NOON prints that are often found in the sun-washed colors.

If you prefer solids over prints for your personal taste or to camouflage a larger body shape, choose print for some small portions of your outfit. For example, a paisley scarf or a flowered blouse will soften a solid skirt and blazer. If you use solid colors without a blending print, make sure your style or fabric gives you the soft gentle look of HIGH NOON.

## Styles of HIGH NOON

Picture yourself standing on the bluffs at HIGH NOON in a dress that sways with the gentle breezes. You have on a garden party hat with silk flowers circling the crown. With this image in mind you will be able to translate this soft swaying style into your everyday wardrobe. Skirts are best that have a flair to them, the type that move when you walk. For your evening clothes try tiny pleats that flip up at the bottom and

bounce along with you. Nothing should be stiff or starched on you. Blouses should have bows, little lacy edges on the collar and cuff, or soft flowing ruffles down the front. Dresses with full sleeves and gathered yokes or other touches of softness are always superior choices. If you are slim-hipped, pleated pants will be great with your gentle look.

Blazers and tailored items can be worn as long as the outfit has soft styling somewhere. For a businesswoman, tailored styles may be expected and you can maintain your personal image if you incorporate a soft silk shirt with a simple suit. An outfit with a flaired cream wool skirt, a shell pink bow blouse and a watercolor plaid blazer is a very classy, successful business look, but it is not so severe that it detracts from your natural beauty.

For a special evening out, a blouson styled dress with full sleeves and lace down the front has a soft, elegant style. Or for a casual at-home look, use a watercolor plaid blouse with a lace-edged collar and a pair of medium colored pleated pants.

Whatever your lifestyle, you can adapt some of these touches to any outfit you put together and always have your soft and gentle look.

### Fabrics of HIGH NOON

The choice of fabric influences the overall look you create for yourself. Fabrics with feel add to your HIGH NOON texture and give you a natural touch.

In the cold weather of winter use fabrics that are soft and warm: velvet, velour, flannel, and wool crepe. Hand knit looks are always appropriate for the HIGH NOON, especially if they are made of cashmere, angora, or mohair. Plush corduroy and ultrasuede are also touchy fabrics which fit your winter mood.

As the weather warms up, keep that same soft feeling in lightweight fabrics such as nubby linen, madras, raw silk, and dotted swiss. Fabrics like crepe de chine, Qiana, and silk are excellent for shirts and drapey dresses. Cotton jersey in a T-shirt style dress has a light touch and a casual HIGH NOON look. Whether you desire a formal or a casual image, fabrics like these will accentuate your subtle sunny style.

Keep in mind always to use some colorful accent in every outfit and to use predominantly medium to light intensity colors. Avoid anything with a light-dark contrast.

### Perfect Outfit of HIGH NOON

Because it is so easy to overpower the delicate coloring of the HIGH NOON girl, special caution must be taken. Don't try to capture the contrasting drama of the MID-

NIGHT, for you are exactly opposite and your face will fade away if you wear a black and white striped dress.

Your ultimate aim is to have clothes in your soft rainbow colors, with water colors or floral prints, gentle flowing styles, and textured, natural fabrics. Picture the lovely heroines in romantic southern movies, standing calmly at eternal garden parties and you will have your vision for your classy clothes. A perfect dress would have a light background with clusters of pastel flowers and a satin ribbon around the waist.

An ensemble would be effective in a rosy color, a slubbed silky fabric, a flared skirt, full-sleeved short-cropped jacket, and a print bow blouse with roses in full bloom on a neutral background. The muted rose is a *correct color*, the *fabric* is *textured* and *natural*, the *style* is *soft* and *flared*, and the *print* is *floral* and *full* with *little neutral*.

For simple daytime wear in winter, a soft wool skirt in seafoam green worn with a crepe floral print bow blouse in green, pink, and cream has everything. Seafoam green and shell pink are correct *colors*, the color *combination* is right, and the shades are predominantly *medium to light*. The floral *print* has the full feel, the bow gives a soft *style*, and the wool and crepe are touchy *fabrics*. The chances of finding all five things in every outfit are slim, but you don't need every outfit to be perfect.

What if you already have a pair of straight blue slacks with a poly/cotton tailored blouse in a blue and beige paisley? It has the right color and muted combination with medium intensity shades. The paisley print is appropriate, but the straight style and smooth fabric are not. It has three out of the five, and that keeps the outfit alive. Always set your goals high, but be willing to use the pieces you have in the best possible combination while you are working your way to the top.

## Accessories of HIGH NOON

When you follow your guidelines correctly, selection of shoes, purses, and jewelry will become much easier. With the soft wool skirt and floral print blouse, pearls would be a natural choice for jewelry. Shoes in a suede open-toed pump or high heeled strappy sandals would work well. These are all logical choices for your outfit. Pearls or opals provide light accents for the softness of HIGH NOON and are always an appropriate choice. Yellow gold in rings, earrings or pendants gives a sunny glow. If your hair is gray, then white gold is your metal. Silk flowers or seashells give a summer feel year round and a pink scalloped shell on a satin cord will add the desired softness to a simple T-shirt dress.

Soft, subtle leathers, suedes, straw, or macrame all give the HIGH NOON image for shoes and bags. Shoes need to have a lightweight look: strappy sandals, open-toed pump shoes with crisscross straps, and lacy looking macrame tops. Espadrilles,

especially with open toes, are good for you to use for casual wear.

Purses should have a soft, gentle look such as sack or pouch type styles with gathers along the top or bottom. They can be large or small, but don't let your bag get so big that it detracts from you. Straw purses are naturals for you in the summertime as they fit in with the nubby linens and crinkled cottons. Stay away from stiff, boxy types or patent leathers because they can destroy the soft look you want to achieve.

These are all examples of possible choices for you to use in creating the soft, gentle look of HIGH NOON. You can select items exactly like those suggested for you here, or you can stray a little bit, as long as you use these guidelines:

REMEMBER:
1. Always use your *muted colors.*
2. Always use a *soft, colorful shade.*
3. In every outfit use:
   a. The correct *print,*
       OR
   b. The correct *style,*
       OR
   c. The correct *fabric.*

THREE OUT OF FIVE
KEEPS THE OUTFIT ALIVE

# Chapter 8

XXXXXXXXXXXXXXXXXXXXXXXXXXXXXXXXXXXXXXXXXXX

# 8
# *Afternoon*

*"The sun went down when they were come to the hill . . . that lieth before . . . the wilderness."*
(II Samuel 2:24)

he Feeling of AFTERNOON
What a pleasure to see the beauty of the Southwestern deserts in the afternoon. The sun is starting to settle in the western sky, casting a toasty glow on the terra-cotta rock formations. The cacti topped with rich plum and amber toned flowers are interspersed among the wild poppies. A warm breeze blows the tumbleweeds along the sand and roadrunners hurry along their way. You can almost feel the presence of the Indians as they once were when the desert was their homeland. The afternoon has a subtle richness created by the warm tones of the desert and the glow of the sinking sun.

## Identification of AFTERNOON
The AFTERNOON woman has coloring compatible with the rich tones of the desert. She usually has green, amber, or topaz eyes, and her skin is fair and often freckled. She may have light to medium red hair, golden blond

XXXXXXXXXXXXXXXXXXXXXXXXXXXXXXXXXXXXXXXXXXX

tresses, or soft brown hair with red or gold highlights. The look of AFTERNOON is complimented by soft features, rounded nose, big eyes, and full lips, although more angular features can work well with the dramatic silhouette of the desert.

### Shades of AFTERNOON

AFTERNOON has more shades than any other time of day as the gold sun is casting shadows of farewell across the desert. The expanse of golden sand breaks only when it meets the terra-cotta mesa and these neutrals are accented by touches of salmon pink reflected from the bluffs. The sun picks up the poppies, the plum flowers, the green sage, and scattered pieces of Indian turquoise. As the sun moves, the shadows range from golden beige to brown, from bone to charcoal, and the canyons fill with tones of deep blue. This warm, rich, toasty feeling of the desert in the afternoon will help you remember the shades that are best for you.

### Color Combinations of AFTERNOON

As you hold the desert picture in your mind, you will be able to sense how to combine your colors. Start with an expanse of neutral and accent it with the afternoon shades. As you look in the mirror you should first see your neutral and then be attracted to the salmon pink, plum, turquoise, sage green, or canyon blue. An example of a correct combination would be a chino cloth golden sand dress with the collar, cuffs, and pockets piped in canyon blue. A terra-cotta jump suit with a scarf of desert prints would be striking on an AFTERNOON. Picture a loose weave natural sand dress with the only color being a dramatic piece of Indian turquoise jewelry.

Do you have the idea? Do you see how easy it will be for you to dress in style? First comes the desert neutral and then splashes of color trim or prints.

As for the intensity of your tones they should be in the medium range. You are not a pastel person and even your light neutrals should lean in a medium direction. Black and dark brown are too intense for you, and navy will not compliment your coloring. If you have clothes that are either too dark or too light, bring them into line by adding colorful prints in your medium range. You will always be best in the natural earth tones for your basic wardrobe and your rich desert colors for your accents.

### Prints of AFTERNOON

When I was a child my grandmother had an old Indian blanket she used to place over me at nap time. It had stripes of AFTERNOON colors and was decorated with Indian motifs. What a perfect feel for the prints that will look the best on you. Closely

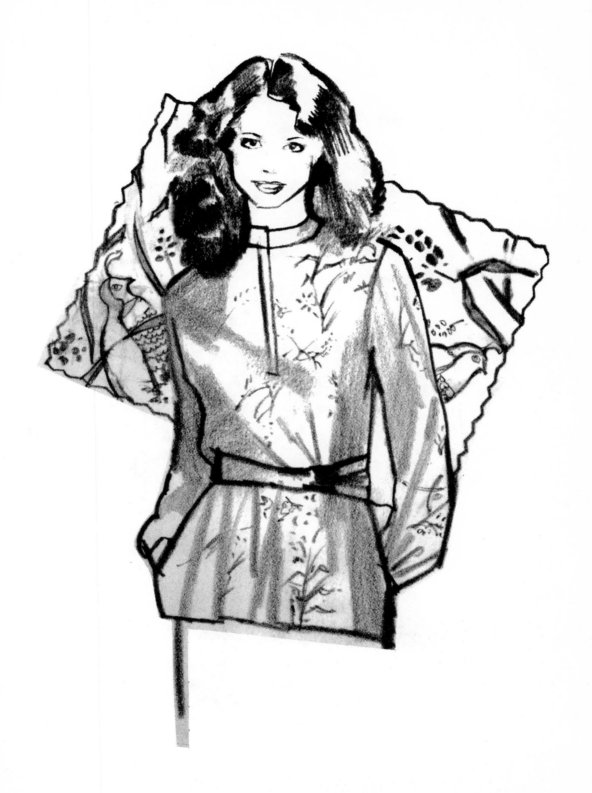

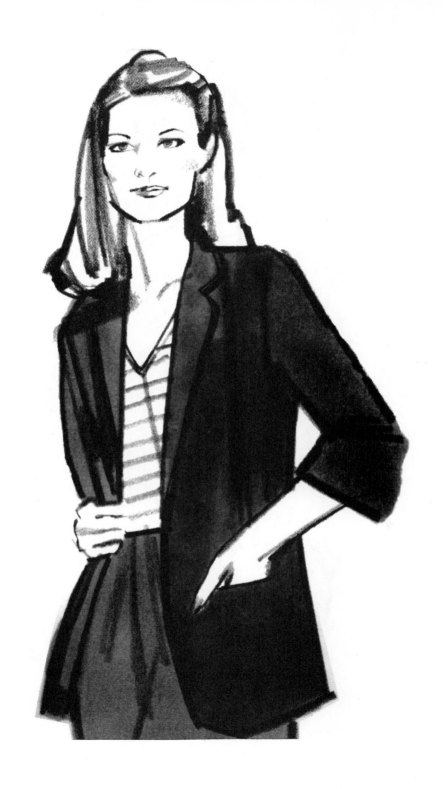

related to the Indian stripes are the madras stripes and plaids using the warm AFTER-NOON colors in a rich medium intensity. Paisleys also are good prints and in all of these—the stripes, plaids, or paisleys—the print takes up the entire fabric and leaves little or no obvious background. Other natural, Western, or desert prints will give you the right look: feathers, leaves, animals, and birds, all in full prints. You are not to wear rows of red tulips across your hem as the SUNRISE may or have dark-light contrast like the MIDNIGHT. Your prints should be of medium value and of a rich nature.

## Styles of AFTERNOON

The AFTERNOON style should be natural, easy, comfortable, and casual. The jackets will be best loose, unstructured, and sometimes with rolled-up sleeves. Crisp tailoring is not for you. Tunic and peasant style dresses are appropriate and the gathered gauze skirts with matching blouses in desert neutrals will put you in the proper mood for the AFTERNOON. Slacks of natural cloth with pleats or drawstring waists will be complimentary on you and they may be worn with madras shirts or full print blouses with dolman sleeves. Bring along a natural fisherman's sweater and you have the casual AFTERNOON look. Western plaid shirts and jeans are especially fitting for the AFTERNOON who is most comfortable in the cowgirl role.

For daytime or business wear don't go for a black wool suit but choose one of your neutrals and change its appearance by the addition of print or plaid shirts, blouses or scarves. The jacket should not be severely tailored and a cardigan in your neutral or one of your accent colors can be used interchangeably with the jacket.

For an evening look you AFTERNOONS can keep the natural fabric but style yourself in the romantic period gowns of the Western movie heroines. You will be dynamic in a golden beige soft cotton dress with matching lace around the high collar and the deep wrist bands holding the long, gathered sleeves. An inset of open lace on the bodice will add drama to the dress and even a sash with a big bow in the back will be appropriate.

AFTERNOONS can look equally attractive in a Western shirt and jeans or a heroine's gown. Both are natural; both are for you!

## Fabrics of AFTERNOON

Since your aim is to have a natural Western look with a subtle richness of color, your fabrics should not be stiff, crisp, or shiny. You will be best in natural, not synthetic, fabrics, and these fabrics will fit your feeling if they are in their natural color also: slubbed flax, Irish linen, soft cotton, or raw silk. Gauze, madras, muslin or

crinkle cotton are familiar fabrics for summer AFTERNOONS and autumn should inspire you to wear sweater knits, wool flannel, soft tweeds, cotton velvet, and suede cloth.

After years of man-made fabrics, *Vogue Patterns* says, "We've gone completely natural; silk, linen, wool, and cotton. We've collected the finest fibers nature has to offer, and put them in an engaging mixture of textures."[1] In the same issue[2] is a full page ad for the Natural Fiber Fabric Club suggesting we join and get back to the basics by buying forty-inch wide one hundred percent virgin wool challis at only four dollars a yard.

## Perfect Outfit of AFTERNOON

Shopping will be so much fun for you as you get the sense of the AFTERNOON feeling and go in search of the perfect outfit. First, you will train your eye to find your own palette of colors and quickly eliminate those that are wrong for you. Second, you will check your combination knowing that a neutral is a necessity and that a medium shade color is an accent. If you want to be perfect you will find some leafy print, plaid, or madras in a casual style, on a natural fabric.

To build your basic wardrobe you could start with a natural flax cardigan with pleated pants or a full skirt in the same golden beige, a raw silk matching blouse with a soft rolled collar, and a wide bronze leather belt. This outfit is medium monochromatic in a natural fabric and color, with a soft style.

A more colorful dress would be a striped madras in salmon, sage, desert sand, with the stripes across the bottom forming a border. This dress is in your *colors*, the *combination* is neutral with medium colors, the stripe is the correct *print*, the madras has your soft *fabric*, and the simple shirtwaist is your *style*. A perfect dress for AFTERNOON!

For casual wear, you could try terra-cotta nubby linen slacks with a soft waistband. Top this with a plaid gauze full-sleeved blouse in medium terra-cotta, bone, and turquoise. If you find you have a straight pair of black slacks that are too good to throw out, use a madras shirt in your colors and don't worry about the combination, knowing that you are aiming for a coordinated wardrobe.

---

1. *Vogue Patterns*, January/February issue, 1982, p. 26.
2. Ibid. p. 19.

Recently I saw a softly pleated skirt made of silk paisley striped material in perfect AFTERNOON colors of plum, sage, and canyon blue with a plum scoop neck blouse. What a dramatic combination for an occasion when you want to be more colorful than neutral.

## Accessories of AFTERNOON

For the natural look of AFTERNOON, knotted rope belts and rope necklaces make appropriate accessories. Shoes edged with rope fit in well and both shoes and bags in macrame will give a natural but dressy look. One-of-a-kind pieces of impact jewelry, ceramics, shells, or semi-precious stones on a satin cord give strong accent to a neutral ensemble. Gold jewelry reflects the AFTERNOON sky, and the copper and bronze metallics will be especially effective if your hair is in the red tones. Since an overall look of unity is important for you, it is wise for you to keep your jewelry, shoes, and bags in the same style. A neutral terra-cotta dress will be exceptional on you with copper jewelry, a bag with at least copper trim, and copper strapped sandals. You don't want to overdo a good thing and look like a copper mine, but you do want a natural harmonious image.

There are many items of nature (aspen leaves, shells, starfish, fossil forms) that have been dipped in gold or bronze and made into jewelry. These meet your need for the down-to-earth look and can be one-of-a-kind pieces. Hammered brass and copper bracelets are exciting additions to your jewelry collection as they will blend with all your clothing, as will natural wood-grain beads and bangles.

Espadrilles in all the earth tones will work for you with pants or skirts and flat canvas shoes with leather trim will give you some sporty variety. You can handle highly polished penny loafers with your pleated pants, and woven leather shoes with wood stacked heels will blend with all but your most formal dresses. The delicate metallic sandals can be used effectively with dresses and with your evening at home or formal clothes. Keep your handbags soft by using macrame, natural lace, woven straw, and suede. You don't want a boxy look or a bag that stands out against your clothing.

Remember that your AFTERNOON feeling is one of unity with nature and a subtle richness. Picture yourself blending into the landscape of the Arizona desert in the afternoon. You don't want to stand out like a Christmas tree in the desert but blend with the soft, rich tones that will enhance your special natural coloring.

REMEMBER:
1. Always use your *soft, rich colors.*
2. Always use a *neutral* and some *medium intensity shades.*
3. In every outfit use:
   a. The correct *print,*
        OR
   b. The correct *style,*
        OR
   c. The correct *fabric.*

THREE OUT OF FIVE
KEEPS THE OUTFIT ALIVE

# Chapter 9

# 9
# *Sunset*

*"In that day shall the branch of the Lord be beautiful and glorious."* (Isaiah 4:2)

## The Feeling of SUNSET

Nothing is more beautiful and glorious than an autumn sunset in New England. Picture yourself walking through the woods with the sinking sun casting a rich, warm glow over everything. Colorful leaves and pine needles carpet the forest floor. The air has a deep scent which fills you with childhood memories of playing in a pile of leaves. Textured tree bark adds to the feeling, and the peeling birch gives dimension. Rabbits, squirrels, quail, and pheasants scurry about preparing for the winter ahead. As the chill in the air nips through your sweater, you head back to the log cabin on the edge of the woods where a fire is blazing brightly. As you sit on the stone hearth looking out at the changing colors in the sky, you see how similar the Shades of Beauty are in both firelight and sunset.

## Identification of SUNSET

You are a SUNSET if your coloring is warm, earthy, natural, glowing; if

your hair is auburn, deep red, or rich chestnut brown; if your eyes are amber, dark brown or olive green. The SUNSET skin tans to a golden tone and others envy your healthy glow. This natural look is most often on a person with soft, rounded features, but the angular bone structure of the exotic ethnic model is also a SUNSET trait.

## Shades of SUNSET

If you feel you fit the form of the SUNSET, you will have an innate sense for the shades of rich beauty which will do the most for you. Think of the glowing colors God brushed across the sky at sunset. Picture the flames of the fire as they burn up the end of another day. These natural, warm colors are for you: olive green, brick red, teal blue, deep aqua, and dusky mauve. Your neutrals are amber, golden beige, rust, warm brown, creamy vanilla, and sunset smoke.

## Color Combinations of SUNSET

Because you represent the feeling of nature, the glow of sunset and firelight, the aroma of an autumn walk in the woods, you must always start your ensembles with a basic neutral. Begin with rust and add teal blue; beige and add brick red; sunset smoke and add dusky mauve; amber and add moss green. The deeper, warmer, and richer your intensities are the better. You are never to be bland or pale, but to splash Shades of SUNSET across the neutrals of nature. Although you will always look best in the colors at the darker end of your spectrum, you can use lighter shades in the summer if you combine them with those in the middle range. You don't want the light-dark contrast look of DAWN, but the richer blends of SUNSET. Don't wear a white blouse with a brown skirt; instead try a creamy shirt with an ethnic print skirt of rust, beige, and brick on a creamy background.

## Prints of SUNSET

As you stroll in the woods at sunset, look up and see little patches of sky peeking through a weave of leaves. This feel of print is for you. The pattern should fill up the fabric with only touches of the background showing. Think for a minute of the kinds of prints that nature has ready for you: leaves, trees, branches, grasses, feathers, birds, wild animals, and peacocks. Other rich full feelings are found in paisleys, plaids, and batiks and in ethnic and Indian blanket prints. Use your prints as much as you want knowing they will add to your fireside glow. If you feel prints add more than richness to your frame use them only as accents, scarves, trim, or blouses under a solid color blazer.

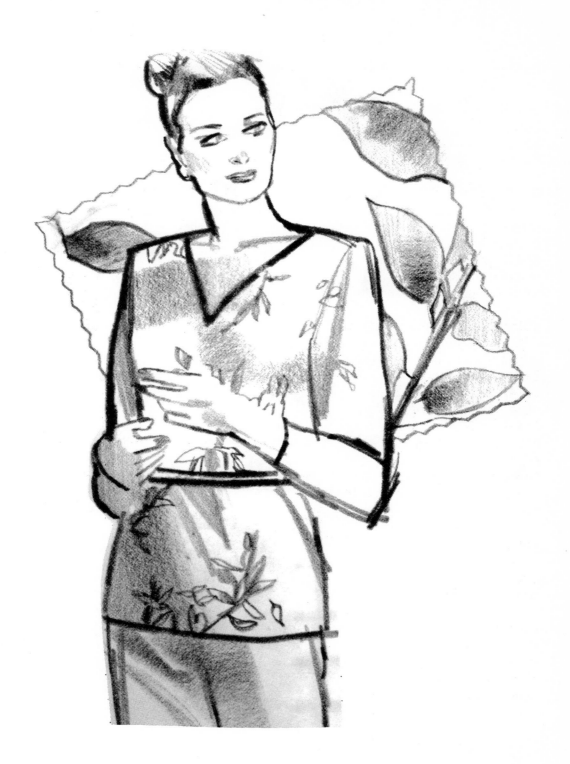

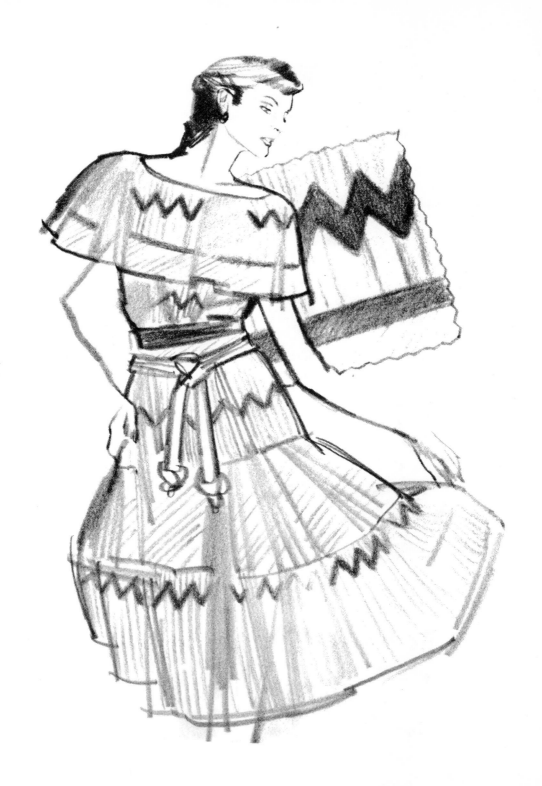

## Styles of SUNSET

SUNSET can be as casual and comfortable as a stroll in the woods or as rich and romantic as a scene in the firelight. For the casual mood choose a country tweed jacket with brown leather buttons and suede elbow patches. Wear this over your pleated brown skirt, your beige pants, or your off-white jeans. Use an oxford cloth shirt in a neutral beige or a tailored teal silk with a soft sweater in rust. A natural-color loose fisherman's sweater will substitute for the jacket with any of these pieces and give the casual SUNSET look. Sweater dresses in your correct colors will provide the comfort image desired if your figure permits, and sporty knits will have the right feel for you.

In the summer use the loose knit T-shirts and full print skirts. Add blouses with rounded neck lines and full or dolman sleeves or try blouson tops over pleated pants.

For the sophisticated SUNSET style step inside by the fire. Picture a group of "YOU's." One stands tall and regal in a rich rust velvet gown with a draped neckline and a strand of copper beads. One of you is in a creamy vanilla dressy knit with pearls, and one has a long plaid skirt in shades of warm brown and brick red and softly tailored silky red shirt topped by a rich brown velvet blazer. Another sits by the hearth in a quilted hostess gown of mauve paisley and talks to the you in the leopard chiffon jump suit with a black velvet belt.

Do you have the feel of the SUNSET woman? Simple elegance, rich colors, textured fabrics, no stiffness, no harsh edges, no black-white contrast. When you go shopping, picture this scene and ask, "Would this outfit blend into my SUNSET style?"

Besides the casual and the dressy, you as a SUNSET may be a candidate for the funky feel. Not everyone can handle these off-beat clothes, but if you like to be a little different and stand out in a crowd, "funky" may be for you. If you are not as thin as you'd like to be, proceed with caution, as these styles tend to be a bit bulky and they do draw attention to your size.

What's fun and funky? Urban cowboy costumes with fancy boots, designer jeans, and plaid shirts with special stitching; Indian beads over suede shirts trimmed with fringe; Russian sabre-dancer styles with belted tunic tops, full-knee pants or dirndle skirts worn with boots or sandals laced up the ankles; Mexican peasant blouses and flowing skirts bound round with a wide sash; cotton gauze from India in dramatic SUNSET colors with natural wrinkles. A soft AFTERNOON dress would be both rich and romantic in a full print of autumn leaves, styled softly with full sleeves and a loose skirt bordered with a simple matching ruffle.

## Fabrics of SUNSET

As you keep in mind the rich textured glow of a sunset, you can grasp the types of fabrics which are appropriate for your exciting look. Choose from cool weather cloth like velvet, velour, tweed, corduroy, wool flannel or wool crepe. Experiment with suede and leather then add hand knits and quilted materials. Warm weather fabrics are gauze, madras, terrycloth, raw silk, nubby linen, muslin, and crinkled cotton. You have such a variety of fabrics to choose from and they range from casual to elegant, from funky to formal. You won't find all of your possibilities in one outfit, but start building a closet full of comfort, richness, depth, and texture.

## Perfect Outfit of SUNSET

We would like to think that all SUNSETS sit forever by the fire in velvet gowns watching the day draw dramatically to a close, but unfortunately most of us have to get up and get moving. In addition to the at-home clothes so appropriate for the glowing SUNSET, "success suits" are also important. For daytime wear the SUNSET should choose a basic blazer and skirt in a neutral color with a natural fabric. Why not a nubby linen suit with a rich paisley blouse or a rust velvet jacket over a matching raw silk dress with a copper belt and shoes. For a more formal look try a wool crepe dress in a dark smoke gray tied together with a medium gray leather belt or a full sash printed with peacock feathers. Use the same sash as a scarf with the natural linen suit and a simple shirt. A pair of olive green corduroy slacks with a wash and wear green, rust, and beige plaid shirt will give a casual look that can be changed by the addition of a loose-knit beige sweater, the linen jacket or the rust velvet blazer.

Do you begin to see how many different outfits you can make when your colors begin to coordinate and you have a sense of your individual style?

## Accessories of SUNSET

The whole feeling of a fireside glow should be carried out even in your accessories. Shoes need to have a texture: woven leather, suede, snake skin, copper or bronze metallics. Straw, canvas, or macrame with rope trim or wood stacked heels fit in nicely with the casual look of SUNSET. For dressy occasions the copper, bronze or pewter metallics give the glow of sunset. Similar textures or metals should be carried out in handbags in satchel or soft basket-weave styles that compliment the comfortable, casual feeling of SUNSET.

Like everything else in your looks, your jewelry should radiate the richness of this time of day: the texture of hammered brass and copper, the elegance of gold dipped

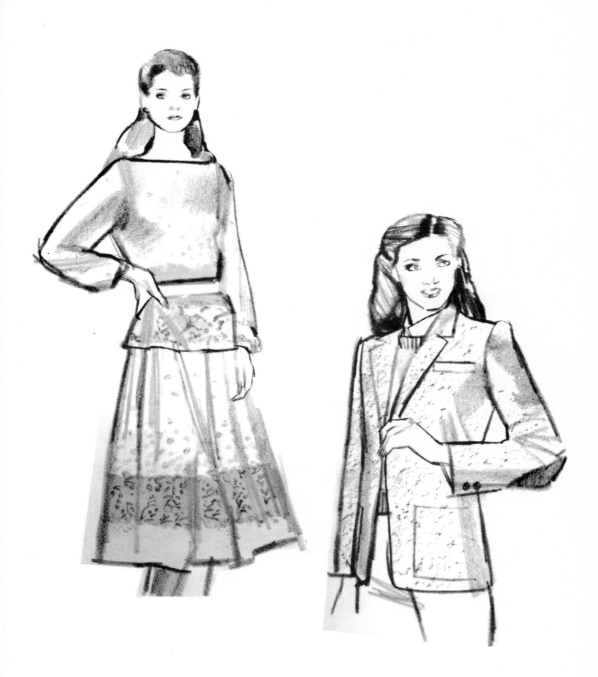

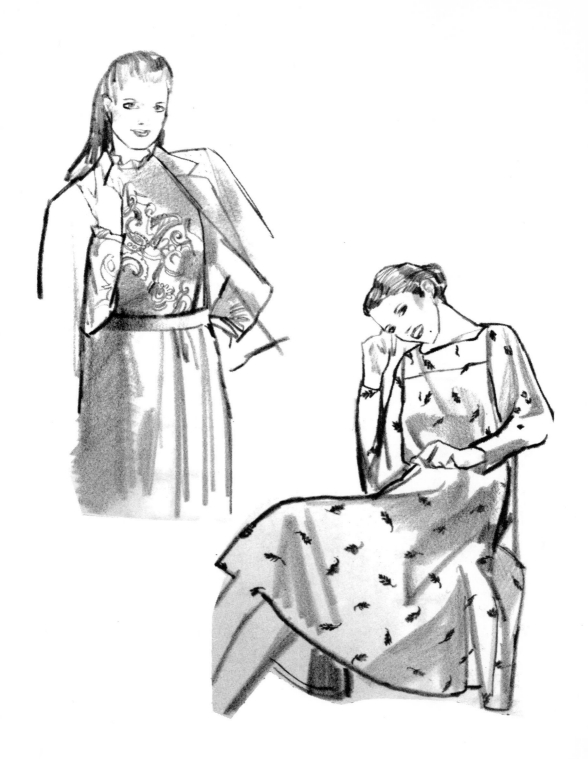

leaves. For the more casual look, sea shells, sand dollars, and ceramic leaves will add a touch of nature as a pin or a pendant. The warmth of SUNSET can be accentuated through dark-toned wooden beads, natural ceramic pieces, and topaz or tiger-eye jewelry. Start searching today for the unique accessories as you begin your exciting journey into the sunset.

Whatever your lifestyle or your budget, if you're a SUNSET, you can always create your fireside glow by following these guidelines.

REMEMBER:
1 . Always use your *rich colors*.
2 . Always use a *neutral color* with predominantly *darker intensity* shades.
3 . In every outfit use:
   a. The correct *print*,
         OR
   b. The correct *style*,
         OR
   c. The correct *fabric*.

THREE OUT OF FIVE
KEEPS THE OUTFIT ALIVE

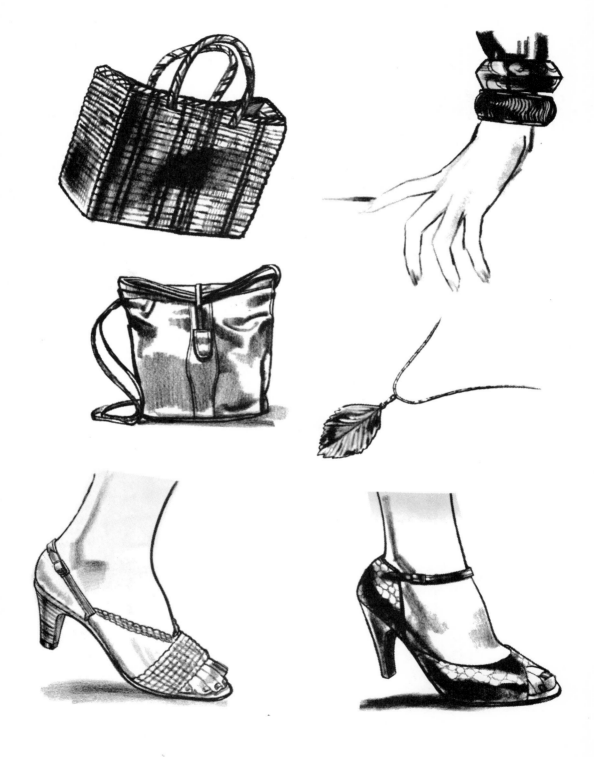

# Chapter 10

✖✖✖✖✖✖✖✖✖✖✖✖✖✖✖✖✖✖✖✖✖✖✖✖✖✖✖✖✖✖✖✖✖✖✖✖

# 10
# Evening

*"For Thou wilt light my candle: the Lord my God will enlighten my darkness."*
(Psalm 18:28)

*T*he Feeling of EVENING

Have you ever wished they'd choose you for the lead in one of those English movies where the heroine lived in a stone manor house and where her biggest decision was which hunt to ride in today? As the sunset and the fog began to move into the moors, the heroine could be seen through the mist riding tall on a chestnut mare who jumped gracefully over the meticulously clipped hedges. As she would come into the faint lantern light of the stable, her bouncing brown hair would settle around her oval ivory face and her big brown eyes would look helplessly around. Instantly, handsome men would emerge from the darkness and assist her off the smooth leather saddle and usher her into the warmth of the manor house. She would change quickly into her long black-watch plaid skirt, high collared off-white lace blouse and her forest green velvet blazer with the antique pearl and gold stickpin on the lapel. As chamber music came from her parlor, she would float to the table where a beautiful banquet had

✖✖✖✖✖✖✖✖✖✖✖✖✖✖✖✖✖✖✖✖✖✖✖✖✖✖✖✖✖✖✖✖✖✖✖✖

effortlessly appeared on the buffet of the mahogany-panelled dining room. Perfectly costumed friends would smile as the butler pulled out the carved chair and seated her in the candlelight.

### Identification of EVENING

The English equestrian look is right for those of you with dark brown or black hair, deep brown eyes, and ivory or light golden skin, even if you've never seen a horse. Picture yourself as a sophisticate, wearing deep, rich colors with the softness of candlelight. Your dark hair and light skin give a natural pattern of contrast which will be increasingly effective as you learn to dress in the same manner.

### Shades of EVENING

English poets have written much about the shades of evening. Shakespeare said, "The bright day is done, and we are for the dark." Lord Tennyson mused, "Twilight and evening bell, and after that the dark." But Robert Browning described this time of day the best as he wrote, "Where the quiet-colored end of evening smiles." What a perfect way to remember your spectrum shades as you picture yourself wrapped in "the quiet-colored end of evening."

The EVENING woman has dignity and her colors are quiet. No loud shocking pinks or lime greens, but the deep rich tones of burgundy, rich blue, pepper red, forest green, aqua, and royal purple. Her neutrals are redwood, the bark browns, and grays into black. Her lighter neutrals are off-white, and ivory beige, representing the candlelight of EVENING.

### Color Combinations of EVENING

EVENING is not a middle-of-the-road person but one with wide contrast. If you have dark hair and eyes with the light skin, you should begin to dress to accent this contrast. In the winter you should use rich deep colors and accent them with your light neutrals. In the summer you should wear your light neutrals or the pastels of your colors with dark accessories. The contrast could be in burgundy velvet slacks and a soft ivory blouse with a cowl neck or in a dress with an off-white background and a rich blue geometric print. A summer ivory beige dress with a brown macrame belt and wooden beads would be a contrast look also.

The monochromatic effect using the dark-light extremes would provide both color and contrast. Think of a royal purple blazer, a purple, lilac, and white plaid skirt, with

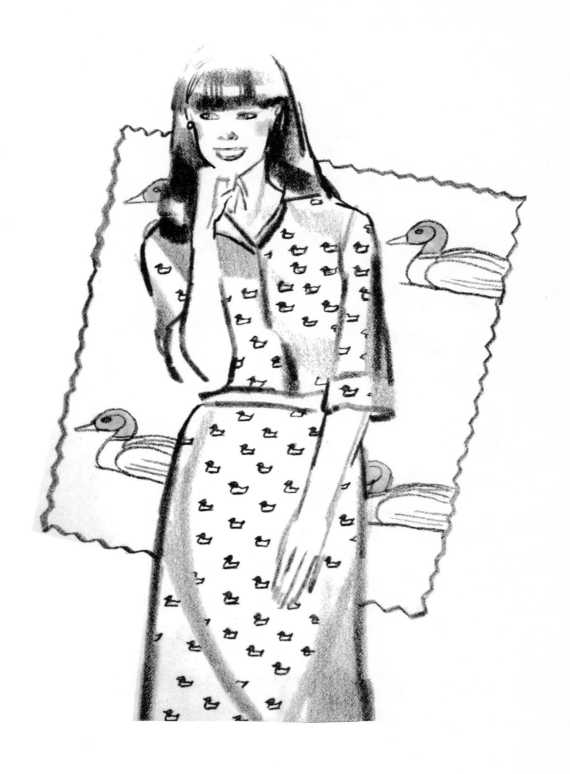

a lilac blouse. This ensemble give the right feeling and color plus the dark-light combination.

## Prints of EVENING

"The quiet-colored end" of EVENING desires prints that are not loud or cluttered, but simple and sophisticated. Plaids are a natural for the EVENING look. I was amazed when I spoke in Calgary, Alberta, and saw all the women in plaid skirts, white blouses and dark velvet blazers no matter what their coloring was. Many complemented their outfits with fluffy feathered lapel pins not seen in the States, but adding a British touch to their EVENING look.

Geometric prints in moderation can be very effective. You might try a striped diamond print on a simple shirt to wear with a sweater or jacket.

Picture a burgundy crepe dress with collar, cuffs, and border of ivory with a burgundy Greek key motif. Animals and birds as you can imagine in the English countryside will give you a unique style: brown quail on a white background, mallard ducks on a pond, or geese in the evening sky. Since border prints are very effective on an EVENING, you will be excited if you walk into a store and see the perfect dress. A silky polyester in a light pepper red with a border of deep red, forest green and ivory beige paisley has the right fabric, color, light-dark combination paisley print, and rich sophisticated style.

Another exciting dress would be an off-white crepe fabric with a forest green border backing up an English hunt scene on the skirt. Scarves with cat-o-nine-tails, maple leaves, or Scottish thistle will always be wise investments as they will correctly accent the dark blazers or light shirts.

## Styles of EVENING

The EVENING lady has the coloring and style for the "dress for success" look and will get long use out of a basic wardrobe of interchangeable parts in one of her rich colors. A light blue jacket, rich blue pleated skirt, and slacks can also be used with a plaid skirt, coordinating pants, and any number of shirts or bow blouses.

If you are an EVENING the shirt dress is a natural for you as it is your style and is always available in many colors. Remember your need for contrast and add a belt, scarf, or beads. A simple shirt dress can go anywhere day or night and its whole look can be changed by simple accessories.

The English country mood is also well expressed in a sweater dress in a rich color

and a string of pearls for contrast, but be sure your figure is up to the revealing curves the sweater dress will emphasize.

Don't feel you must stay bundled up all summer because your EVENING look needs deep colors and contrast. When it is warm keep the simple styles of EVENING, but don't use the layers you might choose in the winter. An off-white sundress in an A-line style with a dark border would be attractive on you. It has a simple, not fussy, style. It's in a light color with a dark contrast and it has a border effect, all pluses for the EVENING.

Whatever outfit you put together, picture yourself in the rich yet country feeling of the English manor house with you as one of the thoroughbreds. The EVENING style needs to be casual yet elegant, with light-dark contrast, an appropriate print, a sophisticated, tailored style, and either a lightly-textured daytime fabric or a rich romantic EVENING material.

One day as I was working with a group of ladies, one of them said, "Would it be safe to say that these guidelines give you more freedom than it might originally seem?" Yes, these are guidelines to aid you in shopping, not rigid rules to frustrate your life. Color choice is of primary importance, combination will show you how to pull together what you already have, and the right use of print, style, or fabric will definitely make your outfits come alive. If a correct print is on a wrong fabric it will still be acceptable as long as it gives the feel of the EVENING.

## Fabrics of EVENING

As you think of a candlelight banquet in the mahogany panelled dining hall, you will be aware of rich fabrics. Deep colored tapestries will be on the walls and the drapes will be burgundy velvet and gold moire. The seats of the chairs will be upholstered in real suede and the love seat will be covered in a rich blue damask. Put yourself in this scene as you try to get the feel of your fabrics: rich, warm, royal, lightly textured, yet not bulky.

In the winter you will want to be by the fire in velvet, velour, ultra-suede, real suede, light leather, wool flannel, or crepe. Knits will be excellent in cashmere and cables. Corduroy combines a rich texture and range of colors and can be used in both dressy and very casual styles. If you are a little heavy use pinwale and if you are thin you can carry the depth of the wide wale. Herringbone tweeds and hound's-tooth are English country feelings along with the wide variety of wool plaids.

In the summer use lightweight fabrics with a little texture. Raw silk or silk-like polyesters make soft but elegant garments and nubby linen is the right fabric for your

skirts, slacks, and jackets. Madras is light and natural yet textured enough to fit your feel. Any textured cotton types with or without synthetic blends will give a country casual look and you will be appropriate in the open crocheted styles so popular in summer shells.

## Perfect Outfit of EVENING

The EVENING lady's tailored clothes look as if she bought them in England as her daytime outfit starts with brown wool slacks, adds a creamy cable knit sweater and is topped off with a herringbone tweed jacket with brown suede elbow patches. You can almost picture a prize horse trotting up beside her. This ensemble is perfect for the EVENING as it has *dark-light contrast*, it is her eye *color*, the herringbone is unobtrusive *geometric*, and it has a neatly *tailored casual countryside look*.

For those of you EVENINGS who spend much of your time at home or on errands you can still carry out your personal style.

You will also be attractive in wash and wear slacks in any of your colors. A tailored light shirt and a coordinating V-neck sweater with your monogram will be simple yet sophisticated. It is amazing how much class a personal monogram can add to a sweater. Pressed jeans or a denim skirt with detailed stitching will be neat for your casual look combined with a shirt in a denim plaid and perhaps a tailored denim jacket. You can be attractively casual but never be sloppy.

## Accessories of EVENING

For accessories you want items that are casual for your tailored clothes and sophisticated for your dramatic outfits. With a simple print shirtwaist dress or off-white blouse, a single string of wooden beads will give the rich yet tailored look your time of day demands. A thick gold chain also provides an elegant yet easy impression.

As you seek out jewelry unique to your EVENING feeling, you will be excited when you find "just the right piece" for you. A little ceramic mallard duck on a leather cord or a rough cut piece of natural turquoise on a chain would be perfect for you. Wide gold hoop earrings, which would overwhelm a HIGH NOON, will give added drama to your ensemble. Hammered brass and gold-toned metals will give you richness, and wood in beads, earrings, or bracelets keeps you in a natural style.

Your daytime shoes should be tailored. The tasseled leather loafer with a stacked wooden heel was made for you. Deep suedes and natural toned canvases with rope trim will give a simple effect with your sport clothes.

For an EVENING's evening the snake skin sandals in a variety of tones will give a dressy richness to your appearance and the bronze metallics so available today add a dramatic touch.

Your handbags should be of a simple style such as woven leather classic, a briefcase type, or a simple clutch. A large carryall sack is too bulky for you and would ruin the rich sophistication you are creating as your style. If you must "carry-all" use a separate tote bag with the extras and keep your essentials in a smaller bag. I have a large briefcase handbag with a matching purse that fits inside. When I go into a store or a social event I just pick up the inner purse and have all my papers and heavy items in the large bag in the car. Every time I decide to go without the briefcase, I always need something that's in there, so I keep it with me in the car for emergencies.

As you begin to put thought into your wardrobe and accessories, you will get excited over the personal style that will emerge for you and you will be thrilled as people comment on how much better you look.

Don't wait until you have the money to throw out everything and start over. Begin today to modify the outfits you have with touches of the right colors in scarves, blazers and accessories. Even small additions done correctly will enhance your EVENING look.

REMEMBER:
1 . Always use your *rich candlelight colors.*
2 . Always use a *light-dark contrast* with a *neutral.*
3 . In every outfit use:
    a. The correct *print,*
         OR
    b. The correct *style,*
         OR
    c. The correct *fabric.*

THREE OUT OF FIVE
KEEPS THE OUTFIT ALIVE

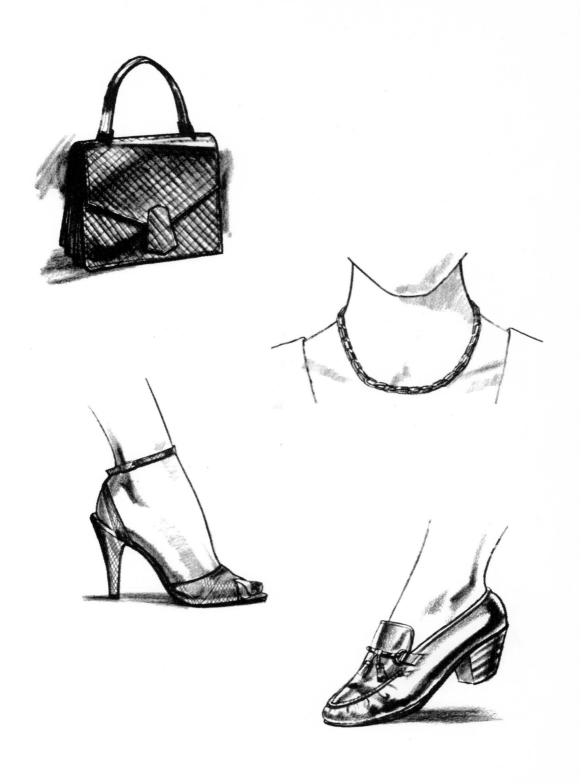

# Chapter 11

✖✖✖✖✖✖✖✖✖✖✖✖✖✖✖✖✖✖✖✖✖✖✖✖✖✖✖✖✖✖✖✖✖✖✖✖✖✖✖✖✖✖✖

# 11
# Midnight

*". . . he made the stars also. And God set them in the firmament of the heaven to give light upon the earth." (Genesis 1:16,17)*

## The Feeling of MIDNIGHT

Everyone loves to look up to the heavens on a clear night and see the stars twinkling against the contrast of a dark blue velvet sky. We get excited when we look out of an airplane window on an evening flight and see the black ground dotted with amber street lights, swept with a white searchlight, and circled with the floods of a stadium. Red lights on the runway line up like rows of bright buttons and green, red, and yellow traffic lights blink in steady rotation. Whether we look up or down, midnight is a time when the background is dark and the accents are light. So it is with the MIDNIGHT woman; her clothing should be of deep colors with accents like the stars in the heavens.

Picture yourself on the most dramatic midnight of all, New Year's Eve. You've come to Jubilate at the Sheraton Universal Hotel. The ballroom is dark with flickers of candlelight at each table. As your eyes get accustomed to the dimness, you see the shadowy forms of the guests as they file in

✖✖✖✖✖✖✖✖✖✖✖✖✖✖✖✖✖✖✖✖✖✖✖✖✖✖✖✖✖✖✖✖✖✖✖✖✖✖✖✖✖✖✖

from the lighted hall. Pat Boone enters wearing a tuxedo, Joyce Landorf is in mink brown lace, and Gloria Gaither is wrapped in pearl white satin.

As the clock strikes twelve and Johnny Mann leads the guests in "Auld Lang Syne," the lights are turned up and you see accents of jeweled colors against the black and white of the tails and tuxes: a ruby chiffon gown, ruffles in sapphire blue, and a sash in emerald green. Midnight is not a moment for pale pink or muted blends. It is a time of color and contrast, laughter and lights, glitter and glamor.

### Identification of MIDNIGHT

Not everyone can handle the stark contrast and the jeweled tones of New Year's Eve, but those of you with light porcelain skin and coal black hair with either ice blue eyes or coal black eyes have this dramatic look that is very rare.

### Shades of MIDNIGHT

If you have the dark-light contrast of the MIDNIGHT, your neutrals will be onyx black, mink brown, plus pearl white and beige. Your jewel tones are emerald green, ruby red, amethyst, coral, aquamarine, and sapphire blue.

### Combinations of MIDNIGHT

MIDNIGHT is dark with twinkles of light, "Fair as a star when only one is shining in the sky" ("Lucy" Wm. Wadsworth). The MIDNIGHT woman must claim this dramatic contrast for herself. To live up to her potential she should use her deep shades with some light contrast and at least one jewel tone for color. A black velvet suit with a pearl white satin blouse and a ruby red silk flower on the lapel is an accurate example. It has dark-light contrast with a splash of color.

If you wore a dark amethyst dress you could improve your look by adding a string of pearls. The dress is dark with color and the pearls give light contrast.

Since you do not have to use a neutral, you could combine the light and dark of one of your favorite colors. A dark emerald green pair of slacks and a blouse with a light and dark emerald plaid fulfills all MIDNIGHT requirements.

### Prints of MIDNIGHT

MIDNIGHT is a clear, dramatic, uncluttered look and to keep this feeling use a minimum of prints. Picture again the sky at midnight, black velvet with diamond stars or remember how the fireworks at Disneyland sweep across the heavens bursting into brilliant lights piercing the blackness. Both scenes are simple and exciting with an

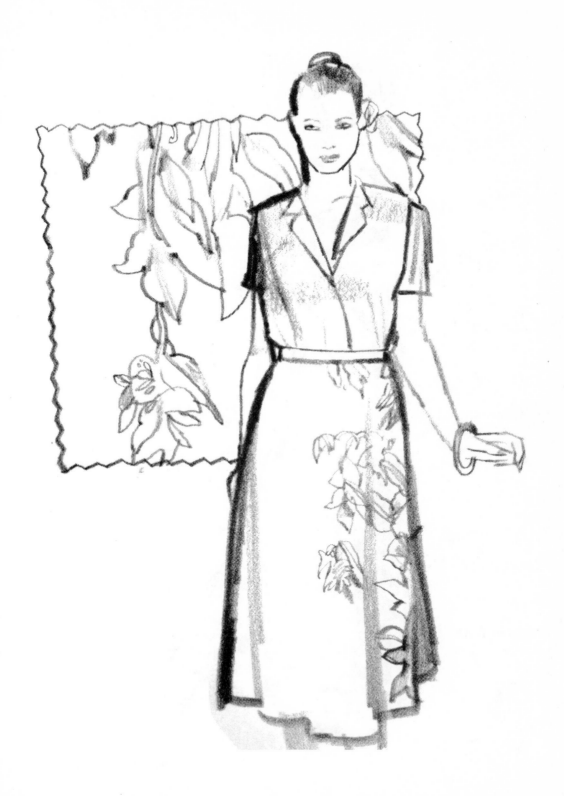

expanse of background and a touch of print. As you hold these scenes in your mind, you will be able to sense the style and print for MIDNIGHT.

A stripe of color on the bottom of a skirt will provide a dramatic effect and a border print will give dash to a simple dress. If you can find a dress with a branch of flowers growing up a flared skirt you will know you have found the ultimate in a striking print on an expanse of background.

Another effective contrast can be used in a stylized border trimming the front of a dress. A sapphire blue dress with a blue print on a white band can be the perfect summer dress with a silk flower accent.

Geometric prints such as interlocking squares give the clean look needed for MIDNIGHT: simple lines on an open background. Similar prints with stripes, triangles, or dots will be boldly effective when used in small quantities such as in scarves or blouses to provide contrast on a neutral.

Always remember yours is the dramatic look, so never clutter yourself up with "cutesy" prints.

## Styles of MIDNIGHT

As you think of the elegance of New Year's Eve in the grand ballroom, images will come to your mind of exciting evening attire. You may picture a one-shouldered gown in black satin with a double ruffle, a dress of smooth sapphire silk with slits up the side of a slim skirt, or a ruby red velvet jumpsuit with a sequin and beaded belt. Each one of these combines drama with simplicity and is a perfect memory of MIDNIGHT.

Much as you might enjoy it, life cannot be one long New Year's Eve. There's work to be done and battles to be won. How can you keep the striking quality of MIDNIGHT in the light of day? Try a poplin jumpsuit, a Mandarin-collared jacket, an ultrasuede blazer, or a blouse with an asymmetrical closing. Look for tunic style dresses and skirts with pleats on one side. For sport, slim straight slacks are best topped with a V-neck sweater or a suede vest over a print shirt.

As a MIDNIGHT you never want to risk being ordinary, so replace old jeans and sweatshirts with neat slacks and a side closing blouse. It doesn't take much money to buy everyday clothes as many discount stores have an endless variety of separates which will give you a quick lift when doing the marketing.

A tunic style dress with rolled up sleeves in one of your light shades and belted in a contrasting dark color will bring drama to midday. For business, a deep purple blazer with pearl white trim and buttons and a purple and white striped blouse will

make an appropriate ensemble. If the skirt has off-center pleats this accent will add to the MIDNIGHT effect.

For a dressy function a smooth wool crepe suit with Mandarin collar and oriental fastenings will be out of the ordinary. A blouse with a high ruffle around the neck and at the cuffs is one possible combination with this suit. The trim and blouse could provide contrast or the suit could be one color and the blouse an open oriental print.

As you get the feel for MIDNIGHT you will begin to have a new excitement in getting dressed each day.

## Fabrics of MIDNIGHT

The fabric in any outfit can take it from casual to dressy and can strongly influence the impression your clothes make. A simple blazer is a classic and gals in every time of day can wear it; however, the fabric from which it is made will dictate its acceptance. HIGH NOON can wear a blazer in pastel linen, SUNSET in brown tweed, and you as MIDNIGHT in black velvet. The cut and pattern may be the same, but the finished look is strongly different. As we think of fabric for MIDNIGHT we share the wish of Wm. Butler Yeats, who said, "Had I the heavens' embroidered-cloths, enwrought with gold and silver light."

You want glamor and excitement in all your clothing, so choose fabrics that are smooth with a special rich feeling. The jewel tones available in Qiana were made for the MIDNIGHT. Whether your dress is basic tailored or evening draped, Qiana will give it the luxurious look you want.

Smooth, not raw, silk and silk-like fabrics fit your needs and velvet is your very best fabric. You do not want bulky knits, but smooth, tightly woven ones. Wool gabardine and crepe, pinwale corduroy, ultra-suede and leather all have the right look for cool weather. In the summer your MIDNIGHT personality can best be served by linen, poplin, canvas, silk, cotton shirting, and Qiana.

As you evaluate your choices remember the necessity of dark-light contrast with jewel-tone colors. Touches of open print with contrast will add excitement, the styles should be classic and dramatic, and the fabric should be smooth and silky. Start training your eye today to seek out the true drama of MIDNIGHT.

## Perfect Outfit of MIDNIGHT

Already I have suggested the wool blazer suit with contrasting trim and striped blouse, the summer dress with print band and silk flower, and the Mandarin suit with a ruffled blouse. These are all perfect outfits for the MIDNIGHT. Another daytime

ensemble could be a ruby red suit in any of your fabrics: velvet, poplin, wool gabardine, or silk. The skirt has two inverted pleats and the contour cardigan jacket gives effortless chic. When these two basics are in your color, many blouses will begin to coordinate. The blouse shown is stripes of ruby and black on a pearl white background. The *color* is right, the *contrast* is there, the *fabric* is yours, the *print* is geometric, and the *style* is MIDNIGHT. A perfect outfit!

A summer sundress could be a pale green with dark emerald trim along the straps and bodice. A cool cotton shirting fabric and a simple A-line style is appropriate for MIDNIGHT. Let's check this dress. It has the right *color*, the *contrast* combination, your *fabric* and *style*. It doesn't have any print but four out of five is more than enough to keep the outfit alive.

If your life-style at the moment is one that confines you to the homefront and your most exciting trip is carpooling to school, you can still look fresh instead of frumpy. Simple machine wash polyester gabardine slacks with a plaid or striped shirt in contrasting colors will give you a lift in a routine day. If you add a ribbon tie and some colorful espadrilles, you have made the ordinary into an outfit. As soon as you can, retire your faded jeans and puckered polyester pants. You do not need to be a social butterfly to capture the MIDNIGHT look, but you must be neat and in your correct colors and combinations.

## Accessories of MIDNIGHT

As you begin to build your basic wardrobe, you will also want to sort through your accessories and add the right touches when possible. Your jewelry should be simple and dramatic. You can dare to be different. Emilie Barnes, founder of More Hours in My Day Seminars and author of a book of the same title, bought two old faucet handles at a garage sale. They were white porcelain with black printing: hot and cold. She strung one at a time on a black satin cord according to her moods, and her unique jewelry always started interesting conversations. Be creative in achieving your striking MIDNIGHT look.

Silver and silver-toned jewelry will be the best metal for your clean feeling. Look for antique pieces or used items and have an eye for the unusual. You might find an old sterling silver baby spoon. For very little money a jeweler can put a clasp on the back and it becomes a one-of-a-kind lapel pin.

My mother found a carved silver needle-holder designed to wear around the seamstress' neck. She put it on a silver chain and gets many questions as to what it is. Don't settle for the dull or ordinary. Think creatively.

If you wear chains, remember that one wide silver chain will be more effective on you than ten skinny ones. Silver button earrings or wide hoops will give dash to a simple or dressy outfit and the same styles in your colors are often available. Crystal and diamonds are the very best for you and of course they can't always be genuine. (Only your jeweler knows for sure.)

Pearls are perfect contrast accents for MIDNIGHT and there are many excellent imitations available today. Since you can only tell the real by biting them, just keep your friends at arm's length and your secret will be secure.

Because jewel tones are your signature colors, it would be perfect for you to have a vault full of emeralds, rubies, and sapphires. If you don't happen to be royalty, you may have to settle for dramatic costume jewelry, but worn with your head high, the jewelry will look straight out of the Tower of London. My mother has a large gold-metal insignia pin with blue and red enamel on it. A college boyfriend gave it to her and it is actually a military academy marksmanship award. It is worth nothing as a piece of jewelry, but when she wears it on a navy blazer, people stop and comment on it every time. The value is not the criterion for accessories, but rather the impact they have on the beholder.

For your shoes the classic espadrille will be perfect. Replace your old casual shoes or tennies with these sleak yet colorful espadrilles. Loafer style shoes, spectator pumps, and T-straps will give you the proper lines. For a dressier look choose sandals with a few simple straps rather than many little ones. Remember you are never to be cluttered or fussy.

Your handbags need to have the same clean lines. Envelope styles and clutch types are right for you and when you need to carry more choose a classic business-like bag in a smooth leather, real or imitation. Lou Taylor bags are excellent for the correct look, long wear, and up-to-date style. Besides the leather-look, suede is acceptable and materials such as summer canvas with contrasting trim make inexpensive yet appropriate handbags. Straw and macrame are too bulky for you and detract from your MIDNIGHT drama.

To create your MIDNIGHT look and keep it consistent, always follow your guidelines.

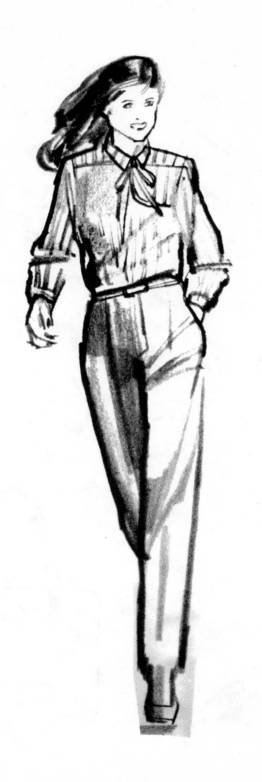

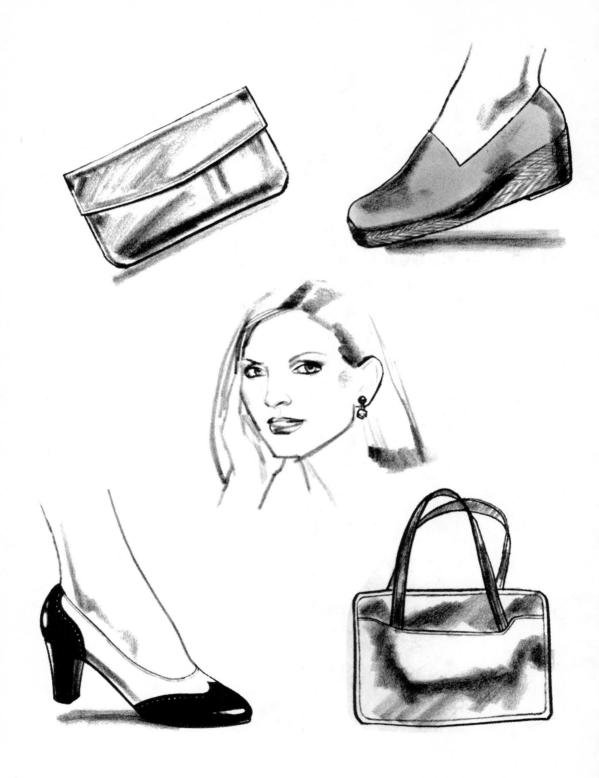

REMEMBER:
1. Always use your *jewel-tone colors*.
2. Always use a *light-dark* contrast.
3. In every outfit use:
   a. The correct *print*,
         OR
   b. The correct *style*,
         OR
   c. The correct *fabric*.

THREE OUT OF FIVE
KEEPS THE OUTFIT ALIVE

# Chapter 12

# 12
# Start With What You Have

*". . . they will become worn out like old clothes, and someday you will fold them up and replace them." (Hebrews 1:11,12 TLB)*

*N*ow that you have found your time on the daily clock and your own Shades of Beauty, you probably realize that not everything you have in your closet is correct for your look. Don't give up! There are some simple steps you can follow to salvage almost everything you own and begin to add things that are right for you. One of the greatest benefits from this whole system is that after you work with and develop these principles, everything you own will begin to mix and match. Instead of having an assortment of clothes and yet nothing to wear, you will turn your closet into a winning wardrobe.

You hold the magic wand to transform your mistakes into a mix and match wardrobe. The steps are so simple you'll wonder why you didn't dream them up yourself.

1. *Empty Your Closet!* "Empty my closet?" you ask. "Couldn't I just push things back a bit?" Of course you can do anything you wish or you can do it right—and right is: EMPTY YOUR CLOSET! Take everything out

and lay your clothes on the bed. Scoop the collection of trivia on the floor out into sight. (One lady said she used a lawn rake and was amazed at what she pulled out of the corners of her closet.)

Once you have removed all the assorted items from your closet, take a good look at the empty space you have available. Some of you may be content with the closet as it is, some may vacuum it and dust the shelves, and those few who are now ready to make this an important room in your home may be inspired to paint it and put contact paper on the shelves. One lady wrote, "I had no idea there was all that space in there. I wallpapered the closet and the shelves and I now keep it all in order as I would any other room."

As soon as you are ready to put the proper items back in your clean closet, you must develop a cold, clear eye as you analyze the future of each piece of clothing. Pretend I am standing beside you commenting on each creation.

2. *Examine Each Item Objectively.* This critical self-examination can be delightful or disastrous according to your attitude about the project, so let's decide we are in this together and it's going to be a game.

   We will work four piles, mentally labeled:
   a. Throw Away
   b. Give Away
   c. Stash Away
   d. Put Away

   Now pick up each piece of clothing and pretend I am viewing it. Some things will be obvious "throw aways." They are the ripped, faded, or disintegrating. March them off to the trash.

   What do you give away? Anything you haven't had on in two years, the mistakes you've bought and never worn—even if they cost "good money"—the fad items that are easily dated, everything that you really know you'll never get into again. Package these items, take them to a charity bazaar or the Salvation Army and wave them a fond farewell. They are only taking up space and wrinkling your other clothes.

   Second-hand clothing stores are also a good way to unload unwanted but useable items. What is trash to you may be a treasure to someone else. One lady from Southern California wrote and told me she made $160.00 from selling old clothes and she used the money to finance the beginning of her new look.

   Whether you sell your discards, give them to missionaries and needy people, or just throw them away, make sure your unwanted clothing is out of your way.

Don't you feel better already? You've gotten rid of your excess baggage. Now let's examine what's left. This is what you are going to keep. You will have some items that are too good to give away but not good enough to wear.

My mother has a holding closet where these ultimate give-aways age until they can be tossed out without guilt. Some of you may have a purple chiffon blouse that your mother-in-law thought was you. It isn't, but you don't dare throw it away. Stash it away and pull it out once a year to wear over to her home for dinner.

You may have a few items of sentimental attachment that you can't bear to throw away. Box them up and label them, but don't let them hang in your current closet. My mother has her bright red poodle cloth honeymoon suit in a box in the garage. We've used it for 50's costume parties, but we don't need it in the house.

Discount stores have sturdy storage boxes for about two dollars. Some are low enough to fit under a bed and are about the size of a skirt. It's amazing how many outfits can be kept in one box.

By now you have thrown away the junk from your closet, bagged up the selections you will give away or sell, and boxed up the off-season or rarely used items. What's left? Clothes you actually wear and that fit you at your current size. Before putting them back in the closet, make sure each piece is clean and in good repair. Don't put anything in your closet that is missing a button, pinned at the waist, or split in the seam. From here on when you reach for a dress, you know it will be ready to wear.

As you hang up the remaining clothes, check them with your colors to see how many are close to what they should be. Let's suppose you are a HIGH NOON and the outfit you have in your hand is a navy blue pencil slim skirt and blazer. To complete the outfit you always wear a red, white, and blue striped tailored blouse. From what you have seen and read here, you suspect that this outfit is not for you, but you're not quite sure and you don't know why.

Flip over to the color chart in the front of the book and see if the navy blue suit with the red, white, and blue shirt fits the guidelines for HIGH NOON. Ask yourself some questions.

Is *it my color*? Check with your *Shades of Beauty* chart. No, navy blue is not one of your colors but since you already own the suit, let's work with it. This first step is the key to salvaging your current closet. If you already own the item in question, consider the color is close enough. Don't cheat like this if you are buying

something new, but if you own it, work with it. We are pretending the color is correct so then we can go on to the next step.

*Is the outfit my color combination*? Look on the chart. For HIGH NOON the combination is to always use a colorful shade and to use predominantly medium to lighter intensity colors. Does the navy suit fit into this guideline? Navy and red are both colorful so that part is right, but you can't cheat here. Both parts must be correct, but red, white, and blue is not a medium to light color combination; instead it is a light-dark contrast, which is wrong for the look of HIGH NOON. Since the outfit must have both a colorful shade and medium to light combination, the navy outfit is wrong and you don't need to go any further with your guidelines.

But you can save it. The main part of the outfit, the navy suit, is a dark color and remember as a HIGH NOON if you use a dark color it must have a medium intensity color with it. If you remove the red, white and blue contrasting shirt and replace it with a blouse of medium intensity you will have a very different look. Suppose you find a bow blouse in a watercolor plaid that has some navy blue with medium blue, beige, and pink. Put that blouse with the navy suit and reevaluate the whole outfit by your guidelines.

Although navy is dark for you, it is not offensive, so we are accepting this basic suit. The blouse is colorful and of medium intensity, therefore it is correct. Once you have determined that the first two essentials are right then go on to the third question.

*Does the outfit have either the right print, the right style or the right fabric*? Yes, the watercolor plaid is a good print for the HIGH NOON look, and yes, the bow blouse makes the outfit the right style. The fabric is probably wrong for a HIGH NOON because most suits are in a gabardine-type fabric, but the suit has enough right things in it. The color is close enough, the color combination is right and the outfit has the right print and style. That makes four out of five, and that saves your navy suit.

Whichever time of the day you are, evaluate all your clothes that are left in your closet by the guidelines for your time to determine if they are right or not. Some things will probably fit, and others, like the navy suit, will need some adjustments. The adjustments could be as simple as adding a dark colorful scarf to an off-white shirtwaist dress to give it color and contrast for the MIDNIGHT look or as complex as finding a rich print blouse with texture to add to a smooth tailored suit for the SUNSET feeling. By following these guidelines, you can save almost everything you presently have in your closet.

If you have a fancy dress that can't be added to or changed, wear it without worry until you can replace it. Don't you feel better now knowing that you don't have to pitch everything out and start all over? One girl who came to me to have her colors done was not in the financial bracket to throw away everything. When I told her she did not have to, she said, "Oh, but I will. I couldn't wear something I know is wrong!" I've always worried about her because I'm afraid that one day I'll meet her husband!

# Chapter 13

✖✖✖✖✖✖✖✖✖✖✖✖✖✖✖✖✖✖✖✖✖✖✖✖✖✖✖✖✖✖✖✖✖✖✖✖✖✖✖

# 13
# How To Have A
# Winning Wardrobe

*"Deck thyself now with majesty and excellency;
and array thyself with glory and beauty." (Job 40:10)*

*O*nce you are ready to purchase some new outfits in your colors
there are some simple steps you can follow that will make your
clothing color-coordinate much more quickly.

1. *Select Two Colors From Your Chart.* Look over your color chart and select
   two shades that you like especially well together and would enjoy
   working with. This choice needs to be somewhat determined by what
   colors are available in the stores (unless you sew and can create almost
   anything).

   If you are a DAWN and you select your dark mink brown and your
   light dusty rose for your first two colors and rose is not available at
   that time of the year, shopping will be difficult for you. As you look
   you may find that light peach is very popular. Great! Work with dark
   mink brown and light peach instead. With your variety of colors some
   of them will always be available, so be flexible.

2. *Purchase a Basic Outfit.* Now that you've selected your first two colors, purchase a basic outfit in one of them (matching jacket, pants, and skirt). If it is wintertime you would be more apt to find the dark mink brown pieces and in spring or summer light peach would be easily available.

Make sure the suit is made of the right fabric, such as wool crepe. Next you need some tops to go with it. You will want to have at least one dressy blouse and one casual top: in the winter a sweater, and in the summer a shirt or T-top. The print tops should have *both* of your chosen colors in them, although they may have other colors too.

As a DAWN you might find a light peach blouse with dark brown pinstripes in a silky fabric with a small ruffle on the collar and cuff. This is a dressy blouse and when worn with the dark brown suit the whole look is right for you. The *colors* are correct as is the *combination*, light-dark contrast with one colorful shade. The pinstripe is the right *print*, the ruffle gives the whole outfit a softly tailored *style* and the silky blouse with the wool crepe suit gives a fabric with a pleasing touch. A perfect outfit!

For more casual outings use a "hand knit" look sweater in dark brown, light peach and winter white varigated stripes. Wear this new sweater with either the dark brown wool crepe slacks or skirt and have a perfect casual look.

Of course you will need shoes also. Some shoes you already have might work. If not, get both a dressy and a casual pair in compatible colors. For this outfit we've created a dressy pair of brown suede sandals. Brown leather loafers or crepe sole type shoes will go with the casual look.

These five pieces plus the two pairs of shoes will equip you for any event that comes up during that winter season.

The next season choose your basic pieces in forest green using your peach and green prints. When that set is complete and you are ready to buy more, choose a color that all your green and peach shirts will go with, such as off-white. Next season you might select an off-white basic outfit with shirts in your steel blue.

Although you may not be DAWN these descriptions will give you the basics on how to build a winning wardrobe.

Listed below is a sample color pattern for each time of the day to use in establishing your personal wardrobe with the basic outfit concept.

## DAWN

*First Set:* _____ Basic outfit:       Dark mink brown
Accent color:       Light peach

*Second Set:* _____ Basic outfit:       Light peach
Accent color:       Dark forest green

*Third Set:* _____ Basic outfit:       Dark forest green
Accent color:       Off-white

*Fourth Set:* _____ Basic outfit:       Off-white
Accent color:       Dark steel blue

*Fifth Set:* _____ Basic outfit:       Dark steel blue
Accent color:       Light gray

*Sixth Set:* _____ Basic outfit:       Light gray
Accent color:       Dark dusty rose

## SUNRISE

*First Set:* _____ Basic outfit:       Dark blueberry
Accent color:       Medium blueberry

*Second Set:* _____ Basic outfit:       Medium blueberry
Accent color:       Eggshell

*Third Set:* _____ Basic outfit:       Eggshell
Accent color:       Medium cherry

*Fourth Set:* _____ Basic outfit:       Medium cherry
Accent color:       Dark grass green

*Fifth Set:* _____ Basic outfit:       Dark grass green
Accent color:       Medium coral

*Sixth Set:* _____ Basic outfit:       Medium coral
Accent color:       Medium aqua

## MORNING

| | | |
|---|---|---|
| *First Set:* _____ | Basic outfit: | Medium heather |
| | Accent color: | Medium fresh blue |
| *Second Set:* _____ | Basic outfit: | Medium fresh blue |
| | Accent color: | Off-white |
| *Third Set:* _____ | Basic outfit: | Off-white |
| | Accent color: | Medium soft green |
| *Fourth Set:* _____ | Basic outfit: | Medium soft green |
| | Accent color: | Dark geranium |
| *Fifth Set:* _____ | Basic outfit: | Dark geranium |
| | Accent color: | Medium aqua |
| *Sixth Set:* _____ | Basic outfit: | Medium aqua |
| | Accent color: | Light cocoa |

## HIGH NOON

| | | |
|---|---|---|
| *First Set:* _____ | Basic outfit: | Medium shell pink |
| | Accent color: | Dark gray |
| *Second Set:* _____ | Basic outfit: | Dark gray |
| | Accent color: | Medium lilac |
| *Third Set:* _____ | Basic outfit: | Medium lilac |
| | Accent color: | Cream |
| *Fourth Set:* _____ | Basic outfit: | Cream |
| | Accent color: | Medium cantaloupe |
| *Fifth Set:* _____ | Basic outfit: | Medium cantaloupe |
| | Accent color: | Light sky blue |
| *Sixth Set:* _____ | Basic outfit: | Light sky blue |
| | Accent color: | Medium shell pink |

## AFTERNOON

*First Set:*

Basic outfit: Medium golden beige
Accent color: Dark salmon

*Second Set:*

Basic outfit: Dark salmon
Accent color: Medium charcoal

*Third Set:*

Basic outfit: Medium charcoal
Accent color: Light turquoise

*Fourth Set:*

Basic outfit: Light turquoise
Accent color: Medium toasty brown

*Fifth Set:*

Basic outfit: Medium toasty brown
Accent color: Dark plum

*Sixth Set:*

Basic outfit: Dark plum
Accent color: Medium golden beige

## SUNSET

*First Set:*

Basic outfit: Medium amber
Accent color: Dark teal

*Second Set:*

Basic outfit: Dark teal
Accent color: Medium rust

*Third Set:*

Basic outfit: Medium rust
Accent color: Medium aqua

*Fourth Set:*

Basic outfit: Medium aqua
Accent color: Dark golden beige

*Fifth Set:*

Basic outfit: Dark golden beige
Accent color: Medium brick red

*Sixth Set:*

Basic outfit: Medium brick red
Accent color: Light smoke

## EVENING

| | | |
|---|---|---|
| *First Set:* _____ | Basic outfit:<br>Accent color: | Light pepper red<br>Dark bark brown |
| *Second Set:* _____ | Basic outfit:<br>Accent color: | Dark bark brown<br>Light redwood |
| *Third Set:* _____ | Basic outfit:<br>Accent color: | Light redwood<br>Dark black |
| *Fourth Set:* _____ | Basic outfit:<br>Accent color: | Dark black<br>Light ivory beige |
| *Fifth Set:* _____ | Basic outfit:<br>Accent color: | Light ivory beige<br>Dark burgundy |
| *Sixth Set:* _____ | Basic outfit:<br>Accent color: | Dark burgundy<br>Light gray |

## MIDNIGHT

| | | |
|---|---|---|
| *First Set:* _____ | Basic outfit:<br>Accent color: | Dark emerald<br>Pearl |
| *Second Set:* _____ | Basic outfit:<br>Accent color: | Pearl<br>Dark ruby |
| *Third Set:* _____ | Basic outfit:<br>Accent color: | Dark ruby<br>Light beige |
| *Fourth Set:* _____ | Basic outfit:<br>Accent color: | Light beige<br>Dark sapphire |
| *Fifth Set:* _____ | Basic outfit:<br>Accent color: | Dark sapphire<br>Light coral |
| *Sixth Set:* _____ | Basic outfit:<br>Accent color: | Light coral<br>Dark onyx |

Each color pattern list has the correct color combination for each grouping. For example, the correct combination for EVENING is to have both a neutral color and light-dark contrast. Every suggested combination has both in it: Light pepper red is light—Dark bark brown is a neutral.

As you begin to work with this chart and develop your own patterns, be sure that they fit the guidelines for your look. By eliminating the mistakes from your closet and using the basic outfit concept you will soon have a winning wardrobe.

# Chapter 14

# 14
# Cosmetics: The Finishing Touch

*"Thy lips are like a thread of scarlet."* (Solomon 4:3)

Rebuilding your wardrobe in your colors will take time and you might not notice a difference in your look right away unless you incorporate the finishing touch—makeup. All the women I work with on an individual-consultation basis have found the information on makeup to be the most useful for immediate change.

One lady, Marge Kruger of Redlands, California, gets constant comments on her new look. Her friends tell me, "Since she had her colors done she glows!" She has not been able to purchase a lot of new clothes in her colors, but she did buy the correct color cosmetics and used them in the right way to play up the soft, gentle look of HIGH NOON. She has a look that flatters her, but is so subtle that her friends did not notice her makeup; they noticed only how she glowed.

Whether or not you are able to redo your wardrobe right away, the correct cosmetics will give the finishing touch.

Many women are afraid to use makeup either because they don't know

what to do with it or because they have seen too many women with overdone, overpowering makeup. When makeup is applied correctly in the right colors it will give you a natural flattering look that will be so subtle your friends notice only how great you look, not the makeup you are wearing.

## Foundation

Mastering makeup starts with using the right foundation. Foundation is the beige-toned makeup that comes in a liquid, cream, or cake form and is used all over the face. Although opinions vary on this subject, it is not necessary to use foundation. But unless you have perfect peaches-and-cream complexion you will find that a foundation gives your skin a smoother, more flawless look. Ladies I work with often tell me that they don't use a foundation because it makes them feel as if they have on a mask. And they are right. Many foundations give you a heavy, cakey feeling.

I find that a liquid foundation rather than a cream or cake is lighter and more comfortable. The liquid foundations come in many different types for any kind of skin. Most foundations have a light moisturizer in them; they are not greasy but do nourish your skin with moisture. These light moisture foundations are good for you if you have normal skin. Normal skin is neither excessively oily nor too dry.

If your forehead, nose and mouth area feel oily by midday your skin is on the oily side. For oily skin you will want to use an oil-free foundation. There are a variety of these available and many of them have special ingredients that absorb excess oil throughout the day. This will cut down on oily shine and help keep your face feeling clean.

If your skin is dry it usually feels tight and often shows more little lines around your eyes and mouth than others your age. For dry skin a foundation with extra moisturizer in it will help. Most of these foundations have the word "moisture" in their name. But whatever your skin type you should consult a cosmetic salesperson to be sure of what kind of foundation is best for you.

Choose the color of your foundation to match the beige color (in the neutrals category) on your color chart. Select the shade that best matches your skin color. If you are fair, use one of the lighter shades, and if you are tan, use one of the medium to darker shades. Many times people try to sell you a foundation that has a lot of pink in it to give you "color." But since the foundation is to smooth out any imperfections in your skin and give you a more finished look, not to change your skin color, you will have a more natural look if the foundation *matches you*. You will later add color on your cheeks, lips and eyes.

Test Foundation

Sea Sponge

Wrong

Right

Before buying a foundation, test it first on your wrist. Test the color on the inner side of your wrist where the tan part of your skin and the light part blend. You want the foundation to match as closely as possible. It does not need to be exact since it thins out when applied, and your own skin color shows through. Once you have selected the right type of foundation for your skin and the right color, try it on your face before you buy it to make sure it feels good and that your skin likes it.

The best way to apply foundation, especially if you are not familiar with it, is to use a natural sea sponge. Get the little yellow sponge at a drugstore and make sure it has a flat side. Dampen the sponge under the faucet and wring it out so it is just slightly damp. Next pour a small amount of the foundation into the palm of your hand—about the size of a dime (a little more for extra coverage)—and mop it up with the smooth side of the sponge.

Spread the foundation over your skin with the sponge. Go over your entire face, lips, cheeks, and forehead. At your jawline flip the sponge over to the clean side and run it along the bone to remove any excess, and to be sure you don't have a line. The look you have should be natural but smoother than your skin. Now don't worry! Once you find the right foundation it will go on smoothly and quickly.

Some of you have darker coloring under your eyes that gives you a tired and unhealthy look. Sometimes these under-eye circles are from allergies or lack of sleep and some are hereditary. Whatever the source, you will want to hide them. Choose a good cover-up. Many cover-ups come in green, white, or yellow. All of these shades must be applied under your foundation because they are not natural colors and you need the foundation to cover them. When you apply foundation over the cover-up you wipe half of it away, therefore defeating the purpose. Select a cover-up that matches your skin as closely as possible. Apply on the darker area *over* your foundation. If the cover-up you use is an "extra-cover" type you may need to dust lightly with a translucent powder to prevent creasing.

## Eyebrows

Eyebrow shapes come and go, but if you follow these few simple steps you will always have the best shape for your face. You may want to alter it somewhat with the fads, but keep the same basic style.

First remove (either pluck or wax) any hairs growing towards the center that stand straight up or grow inward. Next remove any stray hairs from under the outside of the eyebrow. Then feel where the bone ends and goes into the eye socket area. Any hairs that are growing on this underside of the bone need to be removed. Hairs in

this area make you look as if you are frowning. After I explained this to one girl she exclaimed, "That must be why my boyfriend always thinks I'm angry."

Eyebrow pencil needs only to be used to fill in gaps where your eyebrows don't grow. Use a shade slightly lighter than your hair to keep it from looking too harsh. If your hair is blond use a blond pencil. Apply the pencil in short, feather-like strokes and brush them with a brow brush or toothbrush to blend them. The width of your eyebrows should never extend too far. Hold a pencil from the corner of your nose to the outside corner of your eye. The eyebrow should not extend farther than this. If it does, pluck it back to this point. If it does not go that far only pencil it in half as much as you need it. This will keep your eyebrows looking natural and provide a nice frame to accentuate your eyes.

## Eye Makeup

If you're not comfortable with a lot of makeup, start out simply. Select an eye coloring pencil in one of your colors from your chart. Use the dark blue, green, aqua, gray, or the color that matches your eyes. If your eyes are blue, start with the blue. For hazel eyes use the aqua, and a green pencil is best for green or brown eyes. (If you are an EVENING with brown eyes you might prefer to start with the aqua color rather than the green.) The eye coloring pencils are made to be used as a liner for your eyes.

Choose a pencil with a soft lead and test to see if it is soft. Do this by lightly drawing the point across your wrist without any pressure. If the pencil leaves a good, solid line the lead is soft enough not to pull on your eye when you use it. If the lead is stiff it will leave a thin spotty line or no line at all.

Now that you've selected your pencil use it just around the outside corner of your eye. Use a thin line of color just below your lashes on the bottom and a thin line just above your lashes on the top. Many makeup experts suggest that you place the color above your bottom lashes, almost in your eye. I have found that this gives most people a too harsh look, it is not really good for your eyes, and the color washes away. Blend the line up into your lashes on the bottom and down into your lashes on the top. This keeps the line from being too harsh and just gives you a subtle hint of color that will bring out your eye color.

Now add mascara on both your upper and lower lashes. For the MIDNIGHT or EVENING look use black mascara. If you are a SUNRISE you will want to use dark brown. Dark brown or brown/black can be used by everyone else. You can venture into colored mascaras if they are a subtle shade. However, the brown and black

Eye Coloring Pencil

Thin Line Of Color Just Above And Just Below Lashes

Applying Mascara

groupings are more natural looking. I recommend one of the newer 24-hour mascaras that don't smear or run and do not contain fibers. These are especially good if you are not used to using mascara and might rub your eyes. Most mascaras will smear and make big black circles under your eyes when rubbed, but these will stay on until you remove them.

To put on mascara start with the upper lashes and apply it by holding the wand lengthwise and sweeping it from the base of your lashes to the tips. As you get to the tips bend the lashes up a little and hold them there for three seconds. This will give them a more natural looking curl. On your bottom lashes you will find it easier to apply the mascara by holding the wand perpendicular to your eye and running the tip of the wand across your lashes. This gets more mascara on your lashes quicker and it is on your lashes rather than on your cheek. You will then need to straighten your lashes back to their place by going over them once with the wand held lengthwise. Repeat this two or three times, letting the mascara dry completely in between each application. Be sure you have mascara on each eye lash and not just the ones in the middle.

These two steps of eye coloring pencil and mascara are the minimal eye makeup you should use and are excellent for a simple or sporty look. You can change the color of the pencil to match your clothes or your eyes and that little hint of color will add more life and sparkle to your eyes.

If your taste requires a more dramatic look or if you want a more special look for evening, add eye shadow. Start with a powdered shadow in a light color from your chart: light beige, light peach, light pink or light golden color. (For evening this light color could have a little gold sparkle in it.) Apply the shadow on the *entire eyelid area* from the eyebrow to the eyelashes. On the brow bone area it is a highlight shadow and on the lid this light color will be a base for the other shadows and will help them go on smoother and more evenly, eliminating dark blotches of color.

The next step is to use a darker natural shade for drama and contour. If you are a SUNRISE, MORNING, or HIGH NOON use a powdered shadow in your darkest beige shade. The darkest rust neutral shade will be the best choice for you if you are an AFTERNOON or SUNSET. EVENING, MIDNIGHT, and DAWN should use their second darkest brown shade for the contour shadow.

If your eyes are wide set, it is usually because the bridge of your nose is wide. Use the dark shadow on your eyelid area towards the center and sweep the color on the brow bone to the outside edge. Having most of the color toward the center will visually bring your eyes together.

If your eyes are close together you will use a different approach. Close-set eyes are determined by a thin nose, often with naturally darker skin color on both sides of the nose, and eyebrows that tend to grow deeper and below the brow bone in the center. You already have the light color all over which will lighten the darker area near the nose. Now place the dark shadow on the outside half of the brow bone area of your eye. Blend it smoothly with a brush so you don't have a bold stripe, but instead a subtle shadow.

Some eyes seem droopy, as a full or puffy area above the eyes gives them a heavy look and hides the entire eyelid. If your eyes are like this, apply the dark shadow in a triangular shape with the point towards your nose on the puffy area. The dark shadow visually reduces the fullness and lifts that portion of your eye.

On the other hand, some eyes are deep set. The opposite of the droopy eye, deep-set eyes have a larger portion of lid showing with very little space between the crease and the eyebrow. If this describes your eyes you should use one brush width of the dark shadow just below the crease of your eye. The light shadow is all over and will lighten the darkness of your deep-set eyes and the dark shadow will visually give the crease of your eye a lower and fuller look.

If your eyes do not fit any of these descriptions they are probably perfect shape, with even space between the crease of your eye and your eyebrow. To add more drama to your eyes use your dark shadow in an even band of color (one brush width) above the crease of your eyes. Do not put the color as high as your eyebrows.

Adding the light and dark shadows is still quite natural looking, but gives your eyes more color and drama. If you feel comfortable, as I do, with even more color, use your shades on the lid area. Use the shadow to match the eye pencil and in the second-darkest shade.

For wide-set eyes put the color shadow just on the outside edge of the eyelid between the eye pencil and brown shadow. Since you have the light shadow all over and you apply the color with a brush, it will blend smoothly. Close-set eyes need the color in the same place. The difference being the wide-set eyes have the dark shadow on the lid close to the nose and with close-set eyes that same portion will be light and your color will all be on the outside half helping your eyes to appear farther apart.

If you desire more color for puffy or droopy eyes just use a little heavier eye pencil. Since your lids do not show, there is no need to bother with extra shadow.

If your eyes are deep set apply the shadow color all over the remaining lid area. On perfect eyes you can also use the color all over the lid area. For a more subtle look

Wide Set Eyes

Perfect Eyes

Close Eyes

Wide-Set Eyes

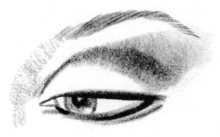

Droopy Eyes

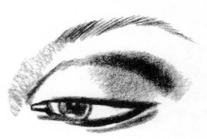

Close-Set Eyes

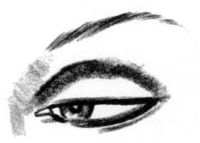

Deep-Set Eyes

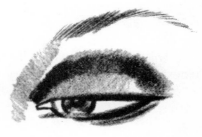

Deep Set

Full Face

Long Face

just put the color in between the brown shadow and the pencil and taper it in towards the center.

The purpose of eye makeup is to flatter and enhance your eyes without looking heavy or overpowering. It should be subtle and well-blended with no obvious lines.

## Blush

It has been said that no matter how healthy you are you should always wear blush. Blush or rouge is the red, pink, or peachish powder or cream that you apply on the cheek area. I always prefer powder because I have found that for most people it goes on easier. Use your red or orange shades from your chart to select your shade of blush shadow.

Blush gives you color and life but is also used to give the illusion of altering the shape of your face. (If you have a ruddy complexion use a foundation with heavier coverage and add blush only where you need it.)

For a full face, either square or round, apply your blush with a brush in a "C" or crescent shape. Bring the blush about two-thirds of the way in from the outside corner of your eye, as shown, and up along the outside of your face with just a hint of color above your eyebrow. This will visually give your face a thinner look and give you more shape.

If your face is long and thin, you will want to shorten it by using your blush in a wide based triangle shape. The point of the triangle should point towards your nose and be only one-third of the way in from the outside corner of your eye. The top of the base of the triangle should start at your hairline even with your eyebrow and end at the hairline even with the bottom of your ear. Apply the color remaining on your brush to the edge of your chin. This will shorten your face and give you a healthy glow of color.

If you do not know the shape of your face, it is probably a perfect oval as the oval has no obvious features requiring correction. For your face shape apply the blush just below the cheek bone in a triangle shape with the point towards your nose about halfway in from the outside corner of your eye. If you are especially pale, you may also use a little blush on your chin, but don't use so much that you have a red blotch.

## Lipstick

Lipstick is one of the most popular forms of makeup and comes in many different types. Frosted lipstick has a little bit of sparkle in either gold or silver frost. Cream lipstick is a creamy solid color, and a sheer lipstick, usually called a gloss, has color,

but since it is sheer it is less intense. The sheer is often preferred by those who are not accustomed to lip color.

To select the right shade for you, first match the lipstick with the color on your chart. Once you have found several that are close, test them on your hand. Then before you purchase test it on your lips by turning the lipstick all the way up and using a lip brush. Brush the color from the bottom of the tube and put it on your lips. Wear it for several hours to give yourself a chance to get used to your new color. Be sure you like it and that it does not change color on your lips.

For those of you who are EVENING or MIDNIGHT use a cream lipstick in your darkest red color: burgundy, ruby, or rust, according to your outfit. This darker shade will accentuate your light-dark contrast. As a DAWN you also want to use your darker shades but use them in a frost to play up your romantic coloring.

SUNRISE and MORNING should use a cream lipstick in the second-darkest shade in your red, peach, or plum color to add to your fresh look.

HIGH NOONS will be best in a frosted lipstick that is your second-darkest or middle shade of pink or peach. The frosted lipstick fits in with your pearly glow.

The look of AFTERNOON and SUNSET is a natural glowing look that goes well with a lip gloss in the second-darkest shade for AFTERNOON and the darkest shade for SUNSET. If you prefer a more intense color you may use a cream lipstick or a golden frosted shade.

If you have trouble keeping your lipstick on be sure you apply your foundation over your lips and dust them with powder before you put on your lipstick. You might also want to ask your cosmetic salesperson to show you some of the new "longer-wear" lipsticks.

## Contouring

Contouring is an aspect of makeup that is not usually used every day but is reserved for special occasions. The most useful contouring is to soften a square jawline, to shorten a long nose, and to thin down a wide nose.

For contouring use a non-frosted eye shadow in your darkest beige shade. You may also use a special contouring powder but it is more expensive and harder to find.

If you have a square jawline that you want to soften visually, draw a line from the bottom of each ear to the outside edges of your chin and shade in the area below the line. Use a large blush-type brush and brush the shadow on the full part of your jawbone. Be cautious in using the shadow. If it looks like dirt you have on too much.

Oval Face

Square Jawline

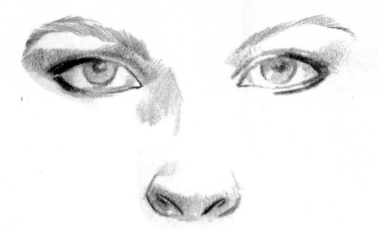

Shortening Long Nose

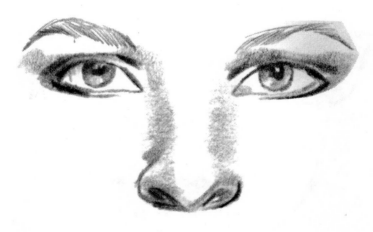

Thinning Nose

Ask a friend who will be honest with you to double check it.

To shorten a long nose use the same brown powder and apply it with your finger to the underside of your nose and blend it up the front, as shown.

If your nose needs to be thinner take both index fingers and rub them in the shadow. Starting on the sides of your nose up near your eyes blend the shadow down towards the tip. To be sure there are no obvious lines blend the color down towards the cheeks.

Each one of these steps is simple and subtle, and if you have any of these problems you'll be amazed at what a difference you'll see in your mirror.

Whether you are used to a lot of makeup or very little, try these new ideas to accentuate your individual look. Be sure all the colors are subtle and blended rather than overpowering. Remember the idea is to see YOU, not your makeup.

When you use your shades with the right combinations, the right prints, fabrics, and styles for you, you will find that the correct cosmetics are really the finishing touch!

# Chapter 15

xxxxxxxxxxxxxxxxxxxxxxxxxxxxxxxxxxxxxxxxxxxxxxxxxxxxxxxxxx

# 15
# *Surround Yourself With Shades of Beauty*

*". . . for all her household are clothed with scarlet."* (Proverbs 31:21)

N ow that you know how important the right colors are for your clothing and cosmetics, you may want to venture even further and surround yourself with Shades of Beauty in your home. For only the price of a few cans of paint you can give yourself a setting which will enhance your coloring and give you a glow. Whenever you are ready to redecorate even one little room, do it in your colors and with your prints and fabrics.

My mother, who, like me, is a MORNING, has done the family room to flatter us. The walls are a soft geranium and the large window has a latticed shelf over it in white with a profusion of green plants cascading down to brighten even the rainy days. On each side of the window are lattice shutters giving an outdoor garden effect. The couches are covered in deep aqua glazed chintz with light aqua and soft geranium flowers with an abundance of pillows. Since Mother has many aqua robes, she fits well into this lovely, cozy room at breakfast.

xxxxxxxxxxxxxxxxxxxxxxxxxxxxxxxxxxxxxxxxxxxxxxxxxxxxxxxxxx

By planning correctly Mother has a room that is in her colors that has a medium to light intensity, that has a floral print with much open background, that reflects her simple but elegant style, and that is in a soft fresh cotton fabric.

Can you see how easy it is to surround yourself with beauty when you give it a little more than a thought? For the same money you would spend on the wrong colors, the wrong prints, and the wrong fabrics, you can buy correctly.

Imagine the romantic DAWN decorating a bedroom with steel blue walls to match her eyes. The draperies and bedspread would be in a subtle silky fabric with muted stripes of blue, peach, and winter white giving a light-dark contrast. Throw pillows in the same colors would have soft self-ruffles and the old chair would be reupholstered in peach velvet. To give the room its final touch, a silver framed picture of a stone castle nestled in the blue shadows of the rosy-fingered DAWN would be placed above the bed. How relaxing to be surrounded by your own Shades of Beauty.

Recently I stayed in a home with a SUNRISE guest room. The walls were upholstered in crisp glazed chintz with bright spring flowers against a white background to match the tailored bedspread. White wicker chairs had grass green pillows and the accent table had a cloth to the floor made of the floral fabric with a pot of silk Easter lilies on top. The colors were clear as SUNRISE, the flowers were upright on a spacious background, the fabric was smooth and crisp, and the style was clean classic. What a joy it was to face the SUNRISE in such a cheerful room.

Can you picture a beach cottage of soft weathered gray shingles and white shutters. Inside, the walls are seafoam green and the old rattan furniture is dotted with shell pink pillows. Seascapes are on the walls and large pink conch shells decorate the coffee table.

As you turn toward the kitchen you are uplifted by the rainbow painted on the wall and ending into a soft copper pot on the counter. A grass rug is under the glass table set with pink place mats and the centerpiece is an old pitcher full of fresh lilacs. The HIGH NOON hostess has surrounded herself with her muted colors, blended beautifully and of medium to light intensity. How soft and subtle to blend the sun-washed colors of the beach into the center of the home.

We have a friend who is a Western art expert and who is an AFTERNOON. Her entire home was designed as a neutral background for her desert paintings. The walls are richly stained walnut and the carpeting is in desert tones. The upholstery is leather and the bedspreads rough natural burlap fabric. Bronze cowboys decorate the tables and the plates and goblets are heavy pewter. Terra-cotta pots hold suc-

culents, and books she has written on Western art adorn the coffee table. She dresses in desert sand and wears strings of genuine turquoise beads. Here is a lady who knows herself and surrounds herself with her own Shades of Beauty.

Could you build a home for a SUNSET? Surely you would put it on the edge of a forest full of falling autumn leaves. You would have roaring flames from a brick fireplace and a ceramic cat would sit on the hearth next to the sleeping Irish setter. If you can picture this scene, you who are SUNSETS can decorate at least one room to reflect your rich auburn coloring. Why not start with brick red paint or face a wall with bricks and redwood shingles? Plan groupings of thick candles set before a copper tray. Use dried arrangements of autumn leaves, natural grasses, and bittersweet and accent them with a softly feathered bird. When you are ready for new draperies don't choose pink flowers, but look for rich full prints of paisleys or animals. Make your home natural with deep rich intensities of your best colors and burnished metals. Your guests will think they're sitting by a glowing fire even if you don't have one.

Remember the description of the English manor house in the EVENING? We have a friend who captured this feeling in the family room of a tract home. She started with beige, brown and pepper red plaid carpeting and her husband put up diagonal planks of redwood on the walls. The couch was reupholstered in beige wide-wale corduroy and the lounger was done in brown tweed. For wall decorations she put up brass plates, English hunt scenes, and an old harness. She found old black lanterns at a garage sale and mounted them. With flickering candles behind the amber glass, the lanterns set the EVENING glow.

She is perfect in her setting as she wears a long plaid skirt, a soft bowed blouse and a forest green velvet blazer when she entertains. Can you see how much more fun life can be when you plan your home to surround you with beauty?

Who would not want to stage the most memorable New Year's Eve of the century? If you are a MIDNIGHT why not prepare your home for that great moment? Paint a wall a dark sapphire blue and mirror the adjoining one. With these two changes you will be in a party mood. Place your table up against the mirrored wall and you have a banquet table. The reflection doubles its length. Place candles down the center in varied heights of holders and use mirrored squares for place mats. Ruby red goblets will give a regal tone and a simple crystal vase of American Beauty roses will add a touch of class. To make yourself the MIDNIGHT focal point, you don your deep blue velvet gown, add strings of crystal beads and stand by the front door holding a single red rose. You are surrounded by your Shades of Beauty.

Remember, nowhere in the Bible does it tell us to be drab and dreary, but to shine as lights. Solomon was regally robed, Lydia sold purple, and the virtuous woman clothed her whole family in scarlet. She decorated her home in tapestry, silk, and linen and surrounded herself in Shades of Beauty. Using the guidelines in this book you can now go and do likewise!

For information on Marita's color-coordination seminars or how you can become a color-coordination consultant, send an inquiry to the address below:

Shades of Beauty
Marita Littauer
1666 E. Highland
San Bernardino, CA 92404